CALIFORNIA'S
HAUNTED
CENTRAL COAST

CALIFORNIA'S HAUNTED CENTRAL COAST

EVIE YBARRA

FEATURING PHOTOGRAPHY BY LAURA DICKINSON

Haunted America

Published by Haunted America
A Division of The History Press
Charleston, SC
www.historypress.com

Front cover image of the Pitkin-Conrow Home courtesy of Laura Dickinson. Back cover images of the Elizabeth Bard Memorial Hospital and Morro Rock courtesy of Laura Dickinson.

Images are courtesy of photographer Laura Dickinson unless otherwise noted.

First published 2018

Manufactured in the United States

ISBN 9781467140935

Library of Congress Control Number: 2018945673

For my sister, Barbie Ybarra Leija, and my brother, Robert Ybarra, for all those great times when we shared ghost stories, as well as the endless times we watched Godzilla *and other scary movies. We had the best times growing up, thanks to Mom and Dad.*

CONTENTS

FOREWORD

We all probably recollect growing up, sharing experiences and feeling that we connected with some people more than others. Maybe the focus of our experiences was camaraderie or friendships when we felt we had few or commonality in how our families were raised. The focus in my life and Evie Ybarra's has had overlap: we grew up together and strove to better ourselves and return to our community to share our learning and our professional careers as educators. We have taught and told stories to our students, the young in elementary schools and the adults we have worked with—Evie at the high school level and I at the college and university levels. This is a tradition also kept alive among family and friends. I furthered this form of expression, teaching and learning, when I earned my PhD. The doctorate required qualitative research, ethnography and cultural research obtained through interviewing people sharing their stories about life and their definitions of success. Through their storytelling, I learned even more about the importance and art of understanding the "spoken words" of others, their true-life experiences, and then recorded and made sense of their realities. I documented these stories and research for others to learn from.

Without individuals sharing their lives and stories, my work would not have been possible; I will always be grateful for their trust and sharing. I continued my own storytelling to others, writing my dissertation and giving class lectures. Evie does her storytelling by writing books and sharing her knowledge at author book signings. The storytelling results in truths about

life experiences in neighborhoods like yours and mine, as well as in lives like ours. My professional career as educator, counselor/therapist and writer has taught me and given me tools to work with. These stories can do the same for you, and that's why I agreed to write this foreword. My life as Evie's childhood friend and teaching colleague, as well as our ongoing friendship, has proven again that learning is never finished.

Storytelling is something people grow up with—some with more "rich tellers" and some with more "listeners" but all tied into tradition. In our upbringing, traditions were shared. There were spooky stories and there were mystical stories, but in the end, they were stories we individuals had to evaluate for ourselves and use as we saw fit, as we continued maneuvering this path called life.

These stories will be interesting and have relevance to a range of people. As an example, many were raised with the idea that our departed (ghosts) visit; that some cultures celebrate ancestors, as in Día de los Muertos; that "boogie men" are out there trying to get us; or that "La Llorona" roams the earth searching for her missing children and may kidnap a child or cause other misfortune. These experiences are a few examples of world phenomena, local experiences and her stories.

We all have a story to tell based on our life experiences. Some may question a story or two, not due to the author's skill but possibly due to the fact they have not had that particular experience (for example, La Llorona), but to undermine their truth, merit or possible existence may imply that we know it all and have experienced it all. None of us has, but we have had different experiences that we learned from; when shared, others may learn from them too.

Most everyone will identify with some aspects of these stories through the author's skill in writing, creativity, years of historical research and time spent talking and listening to people. Having told stories and written in this capacity myself (encountering departed individuals or ghosts, including my family members), convincing others of the validity of the story or data collected is only part of the task. The other task is to keep readers interested in the topic and present what has been shared as fact. Doubting such experiences should not deter the reader from deriving what they may—entertainment, confirmation of their experiences or knowledge—as these experiences are not new and authors of great respect have written stories that others have shared with them for years, including Dr. Oscar Lewis. Ms. Evie Ybarra has succeeded once again, being genuine in her writing and respecting and sharing information she gains.

FOREWORD

Sharing and storytelling are the things life is made of. After years as a writer and educator, Evie has produced a book that will be a refresher of life experiences we have had as well as a tool we can pick up and learn from. You will be entertained while learning something new.

DR. OFELIA ROMERO-MOTLAGH
Educator, Counselor,
Author, *Success as Defined by Mexican-American Women: A Qualitative Study*
Professor of Ethnic Studies, Psychology, Storyteller,
Community Observer and Participant

ACKNOWLEDGEMENTS

I wish to thank everyone who shared their favorite stories with me and for trusting me with your information about the supernatural, ghosts and superstitions. Many of you were very encouraging and answered all my questions.

Thank you to Senior Executive Director Nancy Covarrubias Gill of University Communication at California State University–Channel Islands, for allowing us to photograph buildings on campus. Many thanks to the Santa Paula Blanchard Library, the E.P. Foster Library and the Santa Barbara Public Library. Thanks to Linda Faris, Kristine Hyatt and Jeanie Allred for your words of encouragement. Thanks to Celestine Arnette; your insights were quite valuable, and I appreciate that very much. Thanks to Andrea Howry, the producer of the *Never 30* podcasts for the *Ventura County Star*; your insight and suggestions are always valued, and thank you for sharing them with me. To Dr. Maria Herrera Sobek, thank you for encouraging me with a past project and for always assisting when asked. Your insight and scholarly contribution for your book *Chicano Folklore: A Handbook* is a gem and, it should be on everyone's bookshelf.

To my husband, Robert Sr., your words of wisdom and suggestions are always valuable. Thank you for all of your assistance and patience. To my son, Robert Jr., your upbeat attitude and assistance I shall always appreciate. To my daughter, Elizabeth, and son-in-law, Chris, thank you for all the computer assistance.

We were not the only ones displaced after the Thomas Fire, when more than seven hundred homes burned in Ventura County. Elizabeth and Chris replaced our computers, and for that we are forever grateful. To my sister, Barbara Leija, and my brother, Robert Ybarra, as well as to my nephew, Jeremy Leija, thank you for everything and for your words of encouragement. Jeremy, thank you for all your illustrations as well. You are indeed talented. Yes, we lost our home, but we enjoyed it for as long as we lived there. It's all the memorabilia that we miss. On the bright side, we are fine and healthy and hope to rebuild.

I am so grateful to my acquisitions editor, Laurie Krill, of The History Press, as she skillfully assisted in shaping the content with her suggestions and ideas. She is awesome! Thank you to Ryan Finn, senior editor at Arcadia Publishing and The History Press, for his skillful editing and suggestions. Thank you to Laura Dickinson for her professionalism and her excellent photography skills; the photos are the other half of this book, and they make the stories come to life. James Allen of Hearst Castle, thank you for your efforts in assisting me with the Hearst Castle photographs. Also, thank you to Arcadia Publishing and The History Press for all that you do.

Last but not least, I wish to thank many of my former students who shared their ghost stories with me as part of their creative writing assignments or at our Halloween Festival Celebrations. I taught in Oxnard, Ventura, Fillmore and Santa Paula, and I loved teaching my students how to shape their stories or how to weave them into their family histories. It was a pleasure.

INTRODUCTION

California's Central Coast boasts perfect weather and a beautiful
coastline, and the historical significance of the entire area is
unparalleled. The beautiful California missions have stories to tell,
as do the famous landmarks and unique tourist spots. The Channel Islands
are a gem we take seriously, and we work so hard to protect the flora
and fauna of the area, as well as the Natural Preserves and marine life
on the islands.

Since the beginning of time, man has been very curious about
supernatural beings and events. When the Aztecs first met Hernán Cortés,
they thought he was a god—his coming was foretold by the priests, and
Moctezuma expected this god from the east. The Náhuatl people thought
the Spaniards were supernatural because they had horses (which they
considered large beasts) as well as heavy artillery and cannons. The various
populations of the Mesoamerican world, which included the Mayans and
the Toltecs, also were mesmerized by the power of these new people. Dr.
Maria Herrera Sobek explains Mexican/Chicano folklore in her book
Chicano Folklore: A Handbook, which is a comprehensive explanation of what
folklore is all about. She explained, "[There are] numerous folklore genres
such as myths, folktales, legends, jests, folksongs, folk theater, traditional
customs, folk beliefs, medicine, festivals, folk celebrations, children's songs,
and games and riddles."

Dr. Sobek also mentioned the importance of culinary traditions (tamales,
chocolate, mole and more) and arts and crafts, as well as architecture, dance

and costumes of the culture. This folklore can be applied cross-culturally and includes all world cultures. There is a universal thread of continuity that runs the gamut for all populations.

This book weaves stories with local history. Many of these come from oral traditions and have been passed down from generation to generation. Superstitions abound in many cultures, and included here are the superstitions about mirrors and the Ouija board. La Llorona is part of this tapestry as well, as her cries have been heard by many and her apparition has been seen often. Some of these events do not have logical explanations, and there are many skeptics out there who are not convinced that ghosts or apparitions exist until they see one for themselves. Fairies are another set of creatures that many people accept as real. Some claim to have seen them. The Irish legend of the banshee is a tale similar to La Llorona in that both bring a foretelling of death for those who hear the wailing and laments. The Irish legend speaks of the fairy woman who wails a lament, singing it when a family member dies or is about to die, even if the person lives a great distance away. The family will not have received the news of their loved yet, but when they hear the banshee's wail, that is the first warning sign of a death in the household.

As for La Llorona, in Mexican, Latino and Chicano culture mothers warn their children to behave and not to go out alone at night because La Llorona will take them. If they hear her cries, they must escape quickly, for if they see her, they may meet an early death. According to legend, she has the face of a skeleton and deep, empty eye sockets with which she can hypnotize her subjects. Her wet hair is long, black and stringy from the river or lake from which she came. She is seen as a figure dressed in white. Be wary when you go out in the dark and there is light by the full moon, as La Llorona is certainly out there searching for her murdered children.

Hearst Castle is also full of secrets, and it is a beautiful place to visit. You may indeed meet one of the famous guests from the Golden Age of Hollywood, as many were invited to William Randolph Hearst and Marion Davies's lavish parties there.

Enjoy your read and have a safe ghost-hunting session if you decide to search for any of these spirits. They may find you first!

MONTECITO DEBRIS AND MUD FLOW CREATED A PATH OF DESTRUCTION

After the January 9, 2018 debris flow hit Montecito, California, the path of destruction left twenty-three people dead, and two of those are presumed dead because their bodies were never recovered. Everyone in Montecito, Santa Barbara and the neighboring communities is mindful of the tragedies and continues to come together as a community to help those affected. As the community of hard-hit Montecito grieves and continues to heal, it is aware that it has changed. The San Ysidro Ranch was damaged in the mudflow in the early hours of January 9 and is currently closed. It is hoping to reopen sometime in the future. It will take time to restore Montecito, and homeowners are planning to rebuild their homes or remodel them after extensive water and mud damage. The spirits still linger along the various roads such as Hot Springs Road and Coast Village Road.

The Montecito Inn reopened after the extensive mud damage it had received in the underground parking structure and its first floor. The Four Seasons Biltmore in Santa Barbara reported that it sustained water damage and some mud damage to the grounds, the tennis courts and a few of the guest rooms. It remained closed for five months, and Ty Warner, the owner, continued to pay his six hundred employees during the closure. Now there are new tennis courts, newly landscaped gardens and renovations, and remodeling was done within the hotel after the water damage. The Four Seasons Biltmore in Santa Barbara reopened on June 1, 2018, with much fanfare and support. Ty Warner also owns San Ysidro Ranch.

Spirits and apparitions continue to manifest themselves along the beach, especially on foggy nights. Many people who lost their lives were ripped from their beds in their sleep as the wall of mud, debris, huge boulders and trees swept through. Many who died were not in an evacuation zone.

The claim is that the Thomas Fire caused the debris flow as a result of heavy rain, the hills were vulnerable after the fire as all the vegetation was burned and the soil was in a weakened state.

VENTURA AFFECTED BY THE THOMAS FIRE'S DESTRUCTIVE FORCE

The community of Ventura suffered heavily from the Thomas Fire as more than six hundred homes were burned. The people of Ventura have also

united and come together to help those who lost all of their belongings in the fire. Kevin Costner and his band, Modern West, held a benefit concert to assist the people who were affected by the fire. Many groups also assisted, as did the American Red Cross, United Way, the Salvation Army, Agency on Aging, Catholic Charities and more. Santa Paula, where the fire originated, was also affected, as were the communities of Fillmore and Ojai. Everyone is assisting one another during the rebuilding process. Agencies step in to help those who had no insurance or who were renters and lost all their possessions. The rebuilding is a way to rise up from adversity—to rise up from the ashes stronger than before. Whole communities are rising up and are transformed into stronger cities with open and loving hearts.

JAMES DEAN'S APPARITION ON HIGHWAY 46 AND HIS CAR'S CURSE

DOES JAMES DEAN SPEAK FROM THE WORLD BEYOND?

The college friends were curious about visiting lots of haunted places as they made their journey to Paso Robles and the wine country. Emma told the girls what her grandmother had told her—that James Dean was a heartthrob in the early 1950s and that he was so young when he died in that horrible car accident. The girls drove twenty miles out of town toward the location of the crash site on Highway 46 and Highway 41. They located the James Dean Memorial and parked their car so they could walk around the area. They took photos of the memorial, which is wrapped around a tree.

On September 30, 1955, James Dean was traveling west on State Route 46 on his way to race his new Porsche Spyder at the Salinas, California Airport. His car mechanic, Rolf Wutherich, was riding with him. A San Luis Obispo student by the name of Donald Turnupseed was approaching in the opposite direction in his 1950 Ford. As he tried to make a turn, he did not see Dean's gray car as dusk was upon them. The two cars collided. James Dean was killed instantly. People still pay homage to Dean to this day, as evidenced by the flowers and notes left at the exact location where the fatal accident occurred. A man and his wife approached the young women and explained to them that they were avid Dean fans and had come to see for themselves if this site was really haunted. They walked around just listening to the stillness during lulls in the traffic. The sweet lady offered the girls some chocolate

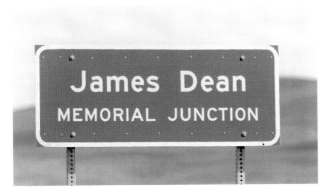

Left: James Dean Memorial Junction sign on Highway 46. *Courtesy of Laura Dickinson.*

Below: James Dean Memorial offerings left by the public, including an American flag and flowers. *Courtesy of Laura Dickinson.*

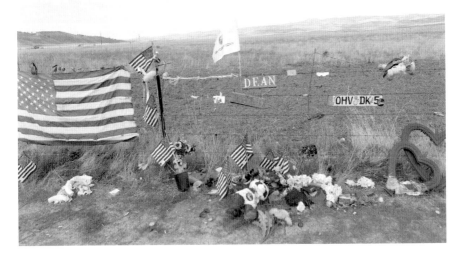

candy bars she had in the car, and she told the girls that it was a distant uncle who had talked to Dean when he filled up with gas at Blackwell's before his fatal journey. Her uncle mentioned that James had received a speeding ticket near Bakersfield and was warned not to drive that car too fast. His mechanic also told him to slow down.

The visitors were leaning against the nice couple's car, munching on the candy bars, when they heard a noise nearby. The older man turned on his flashlight and directed the light against the fence. It was an opossum scurrying along the chain link fence—a big one! The girls screamed at the sight of the large gray creature, but as it ran off, they calmed down. The older couple were sharing their memories of 1955 when the accident happened,

as though it had just happened yesterday. Suddenly, in the far corner of the fence, a white mist developed, as though a fog of sorts was forming on its own. It rose from the ground and widened as it swirled toward the group. The couple froze in fear.

The girls felt goose bumps on their necks and arms. The mist was almost seven feet tall and found its way past the couple and the girls standing next to the car. As it passed them, they felt a sudden chill in the air. They watched this thing float along the side of the road, parallel to the chain link fence, and then vanish. With that, there was a sudden gust of wind that blew the dirt and leaves around. The paper cards and drawings rustled in this wind as the people held on to the fence to keep from being blown across the road.

"What was that?" asked the lady as she turned to her husband looking for answers.

"That was James Dean! Let's go. Let's get out of here!"

Many residents in the area claim that James Dean has returned to the scene of his fatal accident many times. Some have seen the spectral Porsche Spyder racing down the highway, only to disappear into nothingness. He filmed *Rebel Without a Cause*, which made him a star, then *Giant* for George Stevens. In his contract, he was forbidden to go racing. As soon as filming wrapped up, he purchased his Porsche Spyder with the number "130" painted on each door. His car was seemingly cursed. As it was hauled away after the fatal accident, at one point it fell off the bed of the truck and killed the man standing next to it. There are those who insist that this sinister car had a mind of its own.

The Murders of the Reed Family at Mission San Miguel and Other Apparitions

Mass Murder in California in 1848: Are These Spirits Residing at Mission San Miguel?

It was 170 years ago when California recorded its first mass murder. There were six killers, and eleven people lost their lives, including an unborn baby. Several of the sources used to retell this story contradict one another, but all can agree that these horrific murders did happen.

There are several theories as to why ghosts exist, and one of those is that the person still has unfinished business here on earth so they cannot leave. A second theory is that if the person died quickly and violently, the person did not have time to understand that he or she was dead and that it was time to cross over. There are others who claim that some of the deceased do not want to leave, that they are attached to their favorite places. The residual spirits could be the apparitions many have witnessed moving about or heard speaking in muffled voices or crying and wailing. Some may reenact their deaths on a regular basis, repeating them over and over, such as a hanging or jumping off a bridge or out of a window.

In 1834, the Spanish Franciscan Friars were exiled by the new Mexican government, and Mission San Miguel became a secular building. Most of the Salinan Native Americans returned to their native lands, yet a few remained and gained employment. The president of Mexico sold all the California missions to private parties. It was at this time in 1846 that business partners

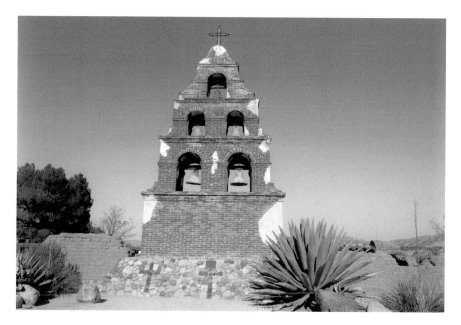

Mission San Miguel Bell Tower. *Courtesy of Laura Dickinson.*

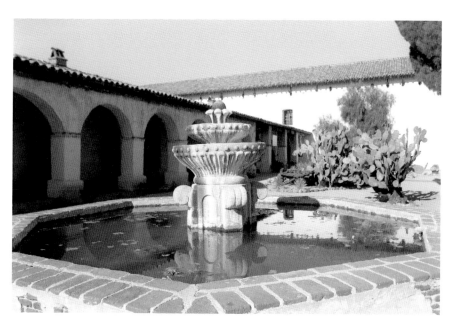

The fountain at Mission San Miguel. *Courtesy of Laura Dickinson.*

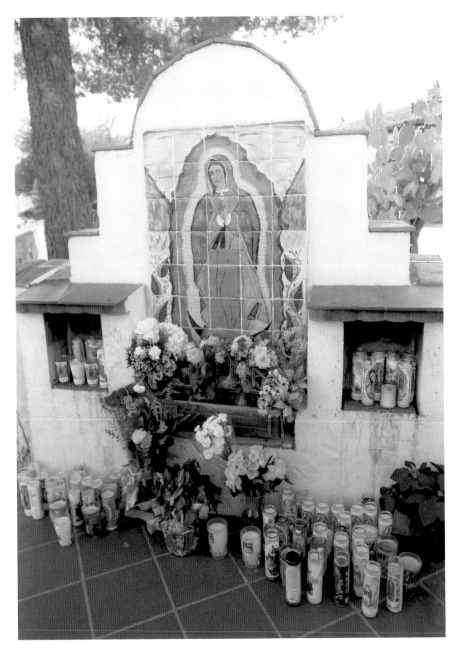

Our Lady of Guadalupe at Mission San Miguel Arcángel. *Courtesy of Laura Dickinson.*

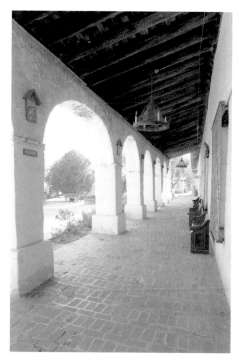

Right: The corridor at Mission San Miguel. *Courtesy of Laura Dickinson.*

Below: Inside the corridor at Mission San Miguel Arcángel. *Courtesy of Laura Dickinson.*

Petronillo Ríos and William Reed purchased Mission San Miguel. Ríos and Reed owned the property, and Reed's family moved in and used part of it as their residence; another of the mission buildings was used as an inn, and a trading post was established as well. In 1848, Mexico lost California, so the two men decided that they would accept the monetary standard of the day, gold, as payment. The California Gold Rush had begun, and many were beginning to pay their debts in gold nuggets. This was an acceptable and useful plan until that fateful night of December 5, 1848, when six ruthless men returned to San Miguel in order to seek out and steal the gold William Reed had collected and hidden at the mission.

The six killers hacked and slashed the Reed family, their guests, their children and their servants to death with an axe, a small sword cutlass and a knife. William Reed was killed first—Sam Bernard took the axe and struck William Reed several times on the head, and his Native American companion stabbed Reed with a knife. Bernard took off Reed's head and hid it in the woodpile. These men went searching for the others, chasing them down one by one and murdering each. Mrs. Reed was getting ready for bed, her baby soon to be born; the midwife Josefa Olivera was assisting her. Josefa's fifteen-year-old daughter and four-year-old grandson were with them. Mrs. Reed was murdered first, in front of the others. They chased down Josefa and her daughter and grandson. They killed the cook in the kitchen and a Native American sheepherder. The sheepherder's grandson hid in some boxes, but he was the last to be murdered. He heard the men running after the others and heard their pleas for mercy and then their screams. The child climbed out of the boxes as the men were searching for hidden gold and begged for his life. Instead of letting him escape, one of the killers picked him up, held him by his feet and slammed his head against the wall. All eleven people, including the unborn baby, were murdered.

JIM BECKWOURTH, THE MAIL CARRIER

One of Jim Beckwourth's usual stops was at Mission San Miguel. He would have a hearty meal, sleep the night away and leave early the next morning on his mail route. He arrived at the mission that evening of December 5 after the murders had been committed, according to the Jim Beckwourth website. To his surprise, the place was deserted. He went in search of someone, and as he

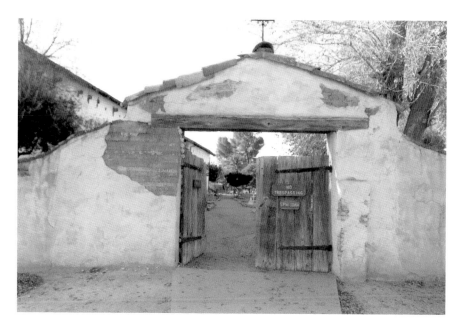

The outdoor courtyard of Mission San Miguel. *Courtesy of Laura Dickinson.*

entered the kitchen, he stumbled upon the body of the cook. He returned to his horse for his pistols and, lighting a candle, commenced a search:

> *In going along a passage, I stumbled over the body of a woman; I entered a room, and found another, a murdered Indian woman, who had been a domestic. I was about to enter another room, but I was arrested by some sudden thought which urged me to search no further. It was an opportune admonition, for that very room contained the murderers of the family, who had heard my steps and were sitting at that moment with their pistols pointed at the door, ready to shoot the first person that entered. This they confessed subsequently.*

It was at this point that Beckwourth took off on his horse and rode for help. He returned with a posse of men, who upon entering the mission living quarters found all eleven bodies in a pile. The murderers had set fire to the building, but it did not burn. The fire had died out. The posse tracked down the murderers. One had drowned and another was killed in the ensuing shootout, while three others were killed by firing squad. The sixth man, Sam Bernard's Salinan friend John, had already

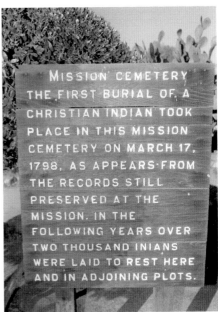

MISSION CEMETERY
THE FIRST BURIAL OF A
CHRISTIAN INDIAN TOOK
PLACE IN THIS MISSION
CEMETERY ON MARCH 17,
1798, AS APPEARS FROM
THE RECORDS STILL
PRESERVED AT THE
MISSION. IN THE
FOLLOWING YEARS OVER
TWO THOUSAND INIANS
WERE LAID TO REST HERE
AND IN ADJOINING PLOTS.

Left: The confessional doors inside the church of Mission San Miguel. *Courtesy of Laura Dickinson.*

Right: This is the Mission San Miguel Cemetery sign noting that numerous Native Americans are buried there, as well as the bodies of the Reed family and the others who were murdered that night by the outlaws looking for gold. *Courtesy of Laura Dickinson.*

escaped and was never found. The murderers were captured in the area of Ortega Hill in Summerland. One woman in the area claimed that she had seen John working at the Los Ojitos Rancho. Legend has it that Cesario Latillade, one of the leaders in Monterey, had claimed one of the killer's rifles as a trophy, but he was killed by it when he accidentally shot himself in 1849.

Today, there is much speculation as to what happened to all the gold the men were after—where had Reed hidden it? Had the Catholic Church located it? Are the Reeds, the other servants and the killers haunting Mission San Miguel? Numerous visitors to the mission have reported seeing a man stepping out of a wall wearing a navy pea coat. Reed used to wear this coat everywhere…was this the ghost of William Reed? Others have seen the ghost of a woman wearing a long white dress covered in blood. Could this be Mrs. Reed in her night dress reappearing? Children have also see the Native American children in the area, with blood on their

This page: Grave markers in the Mission San Miguel Cemetery. *Courtesy of Laura Dickinson.*

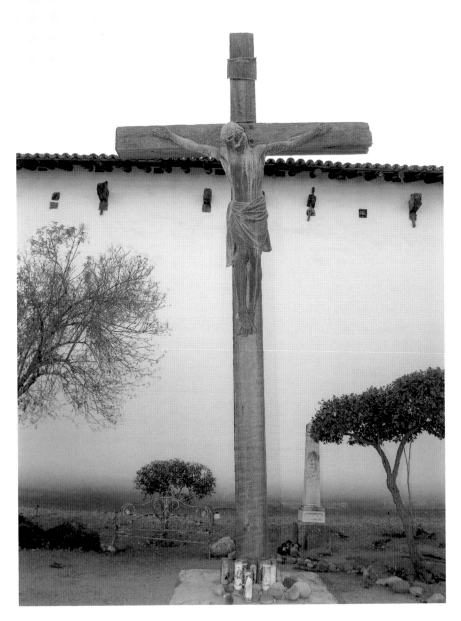

The cross is part of the Mission San Miguel Cemetery. *Courtesy of Laura Dickinson.*

faces, only to vanish before their very eyes. At night, visitors have heard screams coming from inside the kitchen and from the room where Mrs. Reed was murdered. Others have heard footsteps and the sound of people running down the corridors.

MISSION SANTA INÉS AND THE CHUMASH REVOLT: THE GHOST AT MISSION SANTA INÉS

Mission Santa Inés was founded on September 17, 1804, by Father Estevan Tapis. Later, the Americans changed the spelling of the Spanish pronunciation and named the town and mission Santa Ynez.

Mission Santa Inés was located where the Chumash people lived. The Chumash were categorized into three groups: the Barbareños, named after Mission Santa Bárbara; the Ynezeños, named after Mission Santa Inés; and the Ventureños, named after Mission San Buenaventura. Mexico won its independence from Spain in 1821, and during the Mexican War for Independence, the missions were not supported and were denied their annual income. The money that had supported the missions was kept by the Spanish monarchy in a pious fund, but this money was confiscated by the military government in Mexico. The soldiers were not paid, and the presidios continued to pressure the missions to increase production of goods and Chumash labor for the military. This scenario of mutual frustration led, in part, to the Chumash rebellion on February 21, 1824, at Mission Santa Inés. A Chumash man from Mission La Purísima was visiting other Chumash friends at Mission Santa Inés when a verbal confrontation occurred between the Chumash man and a sergeant at Mission Santa Inés. The Chumash man was seized and flogged by the corporal of the guard of Santa Inés. This single act caused the rebellion and uprising by the Chumash people at Mission Santa Inés.

Those who survived the rebellion were rounded up, beaten and whipped, and some were hanged or shot. This occurred simultaneously at Mission Santa Inés and at Mission La Purísima. The Chumash revolt continued at Mission Santa Bárbara long after the conflict at Mission Santa Inés had ended. The Chumash peoples were forced into slave labor and submission by the Catholic priests and the Spanish soldiers, and they received many beatings and punishments. Soon, many Native Americans died as a result of the diseases brought over to America by the Europeans and the

Mission La Purísima building and tree in Lompoc, California. *Courtesy of Laura Dickinson.*

This is the Mission La Purísima Cemetery, where many Native Americans are buried as well. *Courtesy of Laura Dickinson.*

Spaniards, such as smallpox and measles, to which the Native Americans had no immunity.

Today, many have witnessed various apparitions at Santa Inés and hear terrible screams throughout the grounds. The same is true at La Purísima. The apparitions of people dressed in Native American attire have been seen, and spectral phantoms of Spanish priests have been spotted in the chapel. Visitors have heard running footsteps along the corridors as well.

Wandering spirits cannot rest, and it may be because many died violent deaths. When a life is cut short suddenly and perhaps violently, a spirit may return seeking revenge or to warn others. Many specters have unfinished business to attend to when they materialize.

La Purísima Concepción de María Santísima

Buellton is in the center of two historic missions. Mission La Purísima is located in Lompoc, and Mission Santa Inés is in Solvang; both are within a short distance of Buellton. Both missions are historical landmarks, and Mission La Purísima was restored after the Union Oil Company purchased it in order to preserve it as part of California's heritage. This mission was founded on December 8, 1787, by Father Lasuen as the eleventh mission in Alta California. Mission La Purísima has a blacksmith's shop and an apartment for the blacksmith. There is a chapel and an apartment for the padre. Also on the grounds are the kiln, where the tiles and pottery were baked, as well as the weaving and candlemaking rooms. This mission once covered 470 square miles, and it was bordered by the Santa Maria River in the north and the Gaviota coastline to the south. It was home to the Chumash people and the Spanish settlers. The Chumash built the mission in seven years. Here there is a sacred garden and an area known as the Chumash Tule Village, which is a replica of the round houses the Chumash people lived in during the mission era.

The Chumash residents worked the land, harvesting the crops, tending the sheep and cattle, making candles and pottery, blacksmithing and doing leatherwork. Mission La Purísima offers a glimpse into the past, as it has not changed much during the last two hundred years. Travelers stopped at this mission for food and rest and then continued on their journey. This was a center of socialization for the inhabitants, as many local people attended the religious ceremonies, fiestas, weddings, funerals and numerous community events.

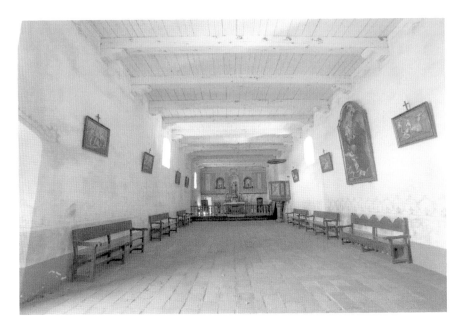

Here is the view of the Mission La Purísima Church. *Courtesy of Laura Dickinson.*

This mission is also haunted by several spectral apparitions that regularly wander the grounds. The apparition of a Chumash man has been seen in the blacksmith's apartment and near the kiln. Voices have been heard within the walls of the mission when no one is present.

There is a story that has been shared by many who live in the area. A family arrived from Mexico and stayed with friends while their own house was being built. This friend owned a huge hacienda, and he enjoyed having friends over. He would host feasts for the people after mass, and there would be dancing, food, music and good entertainment for everyone. The couple from Mexico brought with them a brother and their parents. One night after a celebration at the hacienda, they discovered that the brother was missing. They searched everywhere for him, but to no avail. He was not found until the following day. A group of Chumash workers found the brother's body buried beneath a collapsed brick wall next to the mission chapel. The mission padre helped move the body, and he noticed that there was no blood on the man—they surmised that he had been killed elsewhere and then buried with the loose bricks to make it look like the falling wall killed him.

Who could have done this? The Native Americans knew that the hacienda owner's son was jealous of this brother because he was handsome, strong

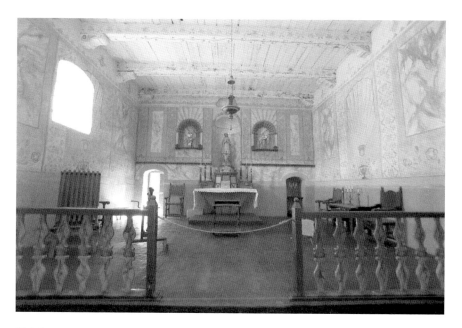

This is the altar inside of the Mission La Purísima Church. *Courtesy of Laura Dickinson.*

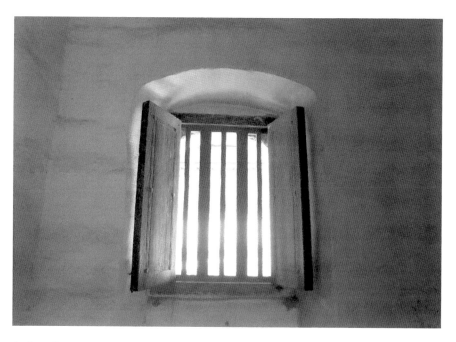

A view of the window from the inside of the mission barracks where the soldiers used to sleep. *Courtesy of Laura Dickinson.*

and very smart. They knew it had been the owner's son. The next day, some travelers from San Buenaventura brought some news sent by the padre at Mission San Buenaventura. Some of the local Chumash people had been crossing the Santa Clara River when they noticed some horse hooves sticking out of the wet sand, and nearby was a hat worn by the owner's son. They dug around it and uncovered the hacienda owner's son and the dead horse as well. The quicksand had brought an end to them both. To this day, the phantom spirits of the brother and the hacienda owner's son have been seen throughout La Purísima at night. They both wander the grounds aimlessly, but not together. A spectral image of a priest has been seen in the chapel lighting candles at the altar.

MISSION SAN CARLOS BORROMEO DE CARMELO

Saint Serra established Mission Carmel in 1771, and it was the second in the chain of twenty-one California missions. Inside this beautiful chapel is where the body of Saint Junípero Serra was buried. Shadows of people appear along the walls and scurry along, but there are no human bodies to match the shadows. Another eerie occurrence is that a mist or fog appears inside the chapel and transforms into a human shape. Voices are often heard inside the chapel and confessional when no one else is present. Upon entering the mission itself, sometimes unseen hands will tap your shoulder or touch your arm. The odor of musty leather permeates the rooms at times, as many of the Native Americans used to work on leather as well as candles and other things when living at the mission.

Saint Serra has been sighted wearing his brown robes and holding his prayer beads in his hands only to disappear in the mission garden. He has been seen pacing near his dormitory and disappears through the wall. At night, the sounds of the Franciscan padres celebrating mass have also been heard, and candles light by themselves. One observer noticed a candle in midair; as he was concerned about the fire hazard, he approached, but the candle blew out and fell to the floor.

Many disagree with Pope Francis's canonization of Father Serra. The current view is that the Native Americans were enslaved and forcibly denied their culture and traditional beliefs by the Spanish padres and the soldiers of the missions.

TWISTED TALES OF CAMARILLO STATE HOSPITAL AND SUNNY ACRES

LINDERO HALL

When Camarillo State Mental Hospital was in existence, Lindero Hall was used as a processing center. This is where all the new patents were brought and where the hospital staff registered the patients and assigned them to various wards and living areas. Lindero Hall has an outdoor courtyard where many of the patients could enjoy the sunshine, and there were certain seating areas for them.

THE BELL TOWER

The Bell Tower at California State University–Channel Islands is well-known to all the students, and it is a landmark building for the university. Visitors and others have claimed to see a lady wandering the halls only to disappear in front of their eyes. A female ghost has been spotted in one of the restrooms in the building, but one cannot prove this as a certainty. Others have seen "faces" in the bathroom mirrors that disappear without saying a word. Some have seen a man near the bus stop in front of the Bell Tower who then disappears.

Near the Bell Tower, underground, is the former morgue of Camarillo State Hospital. This area of the university no longer functions as a morgue,

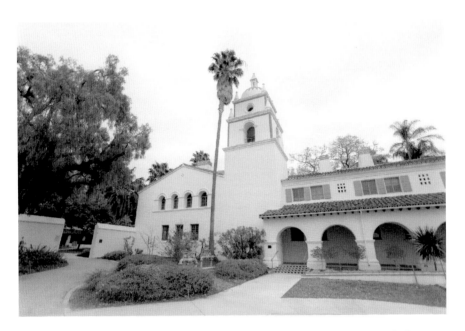

California State University–Channel Islands, the landmark Bell Tower Building. Before becoming a university, this building was built in 1935 and was used by Camarillo State Hospital until it closed its doors in 1997. *Courtesy of California State University–Channel Islands, used by permission.*

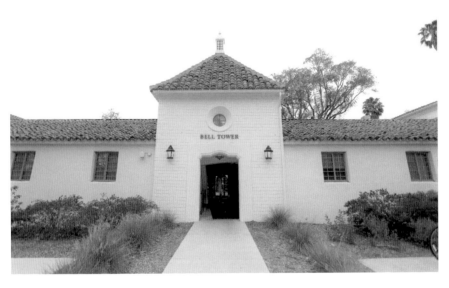

California State University–Channel Islands, the former Camarillo State Hospital. *Courtesy of California State University–Channel Islands, used by permission.*

but some say they've heard strange sounds there and claim that the area still reeks of formaldehyde and other powerful cleaning agents used to embalm bodies.

Curiously, one can still hear children's voices and laughter coming from what used to be the Children's Center located near the Bell Tower. Visitors have glimpsed the apparition of a woman walking the halls, and others claimed that an older lady would stop them and ask for directions to the chapel; when they would answer her, she would vanish.

CAMARILLO STATE MENTAL HOSPITAL

Camarillo State Mental Hospital in Camarillo, California, was opened in 1936 as a psychiatric hospital for the developmentally disabled and for mentally ill patients. Sexual predators or violent criminals were never housed at Camarillo State Hospital and were instead taken to Atascadero. The hospital closed in 1997 amid allegations of overuse of restraints, poor supervision of patients and excessive use of drugs and medications for

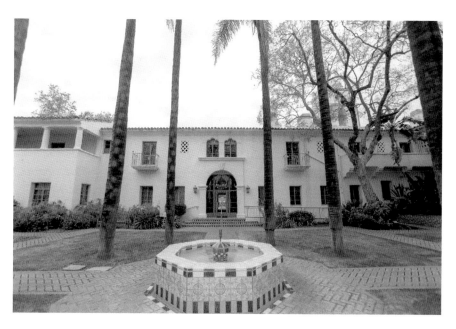

California State University–Channel Islands, Bell Tower Courtyard. *Courtesy of California State University–Channel Islands, used by permission.*

patients. Groups of people advocated for more community-based group homes for the patient population, and many were released. In 1957, the patient population was at its peak at seven thousand, but by 1996 it had dropped to nine hundred. The hospital was closed in 1997. It was intended to become a prison, but the people of Camarillo were against this and instead supported the California State University–Channel Islands concept.

CALIFORNIA STATE UNIVERSITY–CHANNEL ISLANDS

In the fall of 2002, California State University–Channel Islands opened its doors as the new university, and its transformation into an academic center took hold. Students, staff and visitors alike enjoy the renovated campus and the lovely gardens and courtyards with fountains to match. Some of the buildings are still in various states of disrepair and are off limits because they contain asbestos and black mold. California State University–Channel Islands is currently recognized as a leading university and has reinvented the grounds to become a beautiful place to study and attend academic classes. If the spirits wander about, they are friendly. The energy on campus is very positive and the vibes are good.

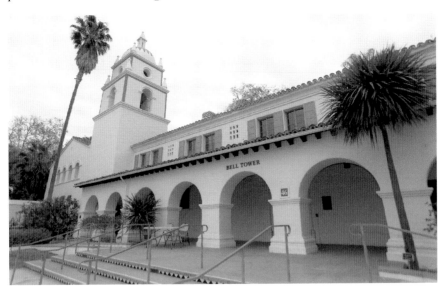

California State University–Channel Islands, Bell Tower Building. *Courtesy of California State University–Channel Islands, used by permission.*

CAMARILLO "SCARY DAIRY"

On the grounds of California State University–Channel Islands, there is an area that once was the self-sustaining dairy farm and slaughterhouse used by Camarillo State Mental Hospital. Many patients harvested crops and milked the cows and fed them, and other patients worked in the slaughterhouse. This work experience served as a way to help the patients function more normally within a schedule and to become successful in an occupation. Myths abound regarding the murders and deaths on the dairy premises. The lore about the dairy's owner involves the patients who labored there. One day, it is claimed, the owner lost his mind and murdered his workers. Other patients are said to have hanged themselves in the dairy and in the now-abandoned barn. The former dairy is fenced off, and the public is not allowed to visit there. When Camarillo State Mental Hospital closed in 1997, there was a fire that destroyed much of the dairy, and only a few walls remain. If you happen to visit there during the day, it is not "scary," per se, but one is overcome with an ominous feeling of fear, sadness and pity for the former laborers who worked the dairy or lost their lives there.

When the dairy was in operation, there was a strong link between the Camarillo State Mental Hospital, the Dairy Farm and the Conejo Valley Mountain Cemetery. Patients who died under mysterious circumstances were buried at the cemetery.

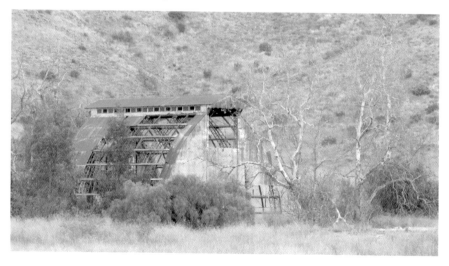

California State University–Channel Islands, former Camarillo State Hospital. This is a view of the old dairy that the hospital utilized to provide milk for all its patients. *Courtesy of Laura Dickinson.*

SUNNY ACRES IN SAN LUIS OBISPO

An empty red brick building, surrounded by empty fields and named "Hell's Acres" by the locals, is known to be a haunted location. Sunny Acres opened on April 16, 1931, as a home for orphans and children who were wards of the court and the State of California. If they had nowhere else to go, they were taken to Sunny Acres. The local judges in the area sent children there as a last resort because it was overcrowded. Some of the cells had steel bars, and some children were isolated for the safety of others. It soon became a jail for children who had no place to go. This place was never an asylum, but it was a detention center. In 1989, a fire started, but no one died because the building had already been abandoned. Teenagers frequented the abandoned building, and they reported hearing disembodied screams and footsteps at night. Some of the cell doors would open and close on their own.

One night, a small group of high school kids went up there to smoke and drink, but no sooner had they arrived than one of them saw an apparition coming down the front steps to the empty building. Within minutes, all five saw the specter. It was a woman dressed in white who had long, stringy hair. She floated away once she reached the sidewalk. They were convinced that

Sunny Acres in San Luis Obispo was a detention home for juveniles and now sits empty. *Courtesy of Laura Dickinson.*

A front view of Sunny Acres. Unfortunately, it would be too costly to renovate the building. *Courtesy of Laura Dickinson.*

ghosts exist. Others have heard someone pounding on one of the steel doors, or they will hear scraping sounds of metal on the caged doors. A sardonic laugh has been noted that would send a spine-tingling chill up the backs of all who heard it. Many have reported a flickering candle going through the inside of the empty building, and a lantern has been seen for miles away inside one of the upstairs rooms. It's as though the ghosts have gathered and are doomed to walk about after dark, as if a premonition of what is to come. Their unfinished business is to keep the former orphans' home alive. The building is completely fenced in, and the doors are tightly shut and locked. There are broken windows one can peek inside if one has a powerful camera lens. The structure is filled with asbestos and mold, not to mention any critters that have settled in the place.

RESIDENT SPIRITS OF SAN SIMEON

HEARST CASTLE IN SAN SIMEON

George and Phoebe Apperson Hearst were parents to William Randolph Hearst, who was born in 1863. George Hearst made millions in the mining industry, and in 1865, he purchased 40,000 acres of ranchland in San Simeon. The family used the property as a camping retreat, and when William was just ten years old, his mother took him with her on an eighteen-month trip to Europe. They traveled extensively, and the trip made a great impression on young William, for years later he would incorporate various European styles of architecture and artwork into his Castle. George Hearst passed away in 1891, as did Phoebe in 1919. William inherited all the land. By this time, the ranch had grown to more than 250,000 acres of land. He contacted the architect who had renovated his late mother's home, forty-seven-year-old Julia Morgan, and hired her to build on what he often called "Camp Hill" in San Simeon.

Julia Morgan was the first woman to receive her architect's license in the state of California. William had first intended to build a bungalow at San Simeon, but after they began discussing plans for the property, he called his idea "La Cuesta Encantada," or the Enchanted Hill, and it grew into the Hearst Castle of today. Julia Morgan spent twenty-eight years on the castle. W.R. Hearst spent more than $6 million on the building and more than $3 million for the art, which was brought in from all over the world. The

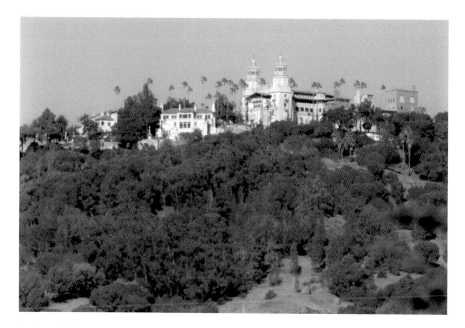

A view of Hearst Castle on the "Enchanted Hill"—La Cuesta Encantada. This image also includes a partial view of the main house, known as La Casa Grande. *Courtesy of Laura Dickinson.*

exterior has reinforced walls, and the Neptune Pool took more than fifteen years to build. Three different versions were built, and the other pool is the indoor pool modeled after the Baths of Caracalla in Rome.

Hearst loved trees and had more than seventy thousand trees planted on the property during his years there. There are magnificent views of the California coast and the sprawling landscape. The interior rooms resemble European castles, and Hearst's dining hall was the inspiration used in the filming of the *Harry Potter* movies for the one at Hogwarts.

The main building is named La Casa Grande, and it has thirty-eight bedrooms, forty-two bathrooms, a library, a billiard room, a private theater and the Roman indoor pool. Of the three guest houses on the property, the Hearst family lived at Casa del Mar for a year. There was a menagerie of animals on the property, from grizzly bears to lions and tigers. Many of the animals were sold, but today the zebras, elk, sheep and goats are allowed to roam freely on the mountainside.

LAVISH PARTIES AND FAMOUS GUESTS

During his lifetime, William Randolph Hearst, or "W R" as his friends called him, fell in love with a beautiful woman, Marion Davies, who was not his wife. Together, they hosted numerous parties for political leaders, artists and cultural icons of the day as well as for the Hollywood elite.
—Julia Morgan

Julia Morgan graduated with a degree in civil engineering from the University of California–Berkeley, where she developed her interest in architecture. One of her professors, Bernard Maybeck, encouraged her to study in Paris at École des Beaux-Arts, where she could pursue her passion for architecture. She was initially refused admission because the Paris École had never admitted a woman. Julia Morgan finally gained admittance after a two-year wait and became the first woman to receive a certificate of architecture. After her graduation, she returned to San Francisco, where she began assisting John Galen Howard with the University of California's Master Plan. She designed the details for the Mining Building, erected in memory of George Hearst, and also designed the Hearst Greek Theater on the Berkeley campus. Phoebe Apperson Hearst asked Julia Morgan to remodel her home in Pleasanton, California. Throughout her lifetime, Julia designed more than eight hundred projects in California and Hawaii.

PHOEBE APPERSON HEARST

As the mother of William Randolph Hearst, Phoebe ensured that W.R. would receive the very best education, and she took him traveling throughout his young life. In 1897, she founded the National Congress of Mothers, a forerunner of the National Council of Parents and Teachers, known today as the PTA. Phoebe financed a school for the training of kindergarten teachers and founded the first free kindergarten in the United States in 1887. She was the first woman to serve on the University of California's Board of Regents, from 1897 to 1919. The Spanish flu, an epidemic in 1918–19, claimed the life of Phoebe Hearst.

Phoebe was a compassionate and kind woman, for she assisted Eve Lummis when Eve left her husband, Charles Lummis.

Lore of Hearst Castle

In today's economy, Hearst Castle would cost more than $500 million to build and furnish. It took W.R. Hearst and Julia Morgan twenty-eight years to build La Cuesta Encantada, meaning the "Enchanted Hill." There are tales that visitors have shared over the years that make Hearst Castle unique but that also highlight its significant history. Besides the private landing strip, which is still used today by the Hearst family, there are the tennis courts where many stars, sports figures and politicians of the day played against each other. Guests could amuse themselves with horse riding, swimming in one of the two pools, wandering the grounds or playing tennis. They were free to do as they wished. The one thing they were expected to do was to join William and Marion for dinner at seven o'clock, along with all the other guests. Lavish parties were also held there, and there are vintage Hearst films of the many guests at La Casa Grande, which means the "Main House," or the "Big House." The movie theater was frequented by many, as this is where W.R. showcased the films he produced starring Marion Davies.

Marion Davies met W.R. in 1917 when she was a showgirl in the Ziegfeld Follies. Davies enjoyed the lavish parties she organized for her friends, and it's claimed that in 1937, she hosted a circus-themed soiree with a full-size merry-go-round borrowed from Warner Bros. Partygoers wore costumes at Ms. Davies's request of the likes of Joan Crawford, Greta Garbo and others. Joan arrived dressed as a baby doll. This location was not in San Simeon but rather in Santa Monica, along the coast. William R. Hearst built the 118-room seaside mansion for Marion so she could host her lavish parties for all their friends.

The Mysterious Death of Tom Ince

A real Hollywood mystery enveloped William R. Hearst, Marion Davies and their guests when they sailed on W.R.'s yacht one weekend in November 1924. Thomas Ince was a well-known independent producer in Hollywood, and in 1910, D.W. Griffith gave Ince his first production jobs. Ince had an enthusiasm for westerns and moved his family to California, where he set up his own studio. His studio initially included an expanse of 460 acres of land, later reaching an astonishing 20,000 acres. There were multitudes of sets,

including saloons, boardinghouses, mansions and a Japanese village. His eye for perfection was legendary. In 1924, Marion Davies and William Randolph Hearst invited Tom Ince and a group of guests for a weekend excursion on Hearst's yacht, the opulent 280-foot *Oneida*. The occasion was celebrating Ince's forty-second birthday, and among the guests included stars, writers, managers, choreographers, one doctor and Charlie Chaplin. Chaplin was in the middle of shooting *The Gold Rush*. The gossip queen Louella Parsons was also part of the entourage. Ince was one day late to the floating celebration and boarded the *Oneida* in San Diego, California.

A lavish dinner was thrown for the attendees, and there was much dancing and drinking for the celebratory group. Ince retired early claiming stomach cramps and indigestion. He was known to suffer from ulcers, and the champagne he enjoyed at dinner aggravated his condition. The following day, Ince was taken off the yacht with a doctor in Del Mar, and Ince's wife was summoned as well as his own personal physician and his own son. He returned home to Los Angeles, where he died three days later. Dr. Ida Cowan Glasgow cited heart failure on the death certificate.

The rumor mill went into overdrive. The unofficial story is that Hearst had shot Ince in a jealous fit of anger in a case of mistaken identity. He meant to shoot Chaplin but missed and hit Ince instead. Hearst suspected that Charlie and Marion were having an affair, and he attempted to stop them. One of the myths is that one of Chaplin's servants saw Ince bleeding from a head wound. Later, Hearst expanded Louella Parson's syndication columns in his media empire and gave her a lifetime contract in exchange for her silence about the tragic incident. Patricia Hearst, William's granddaughter, wrote a novel about the incident with Cordelia Frances Biddle, *Murder at San Simeon*, in which Davies and Chaplin are depicted as lovers and a jealous Hearst shoots Ince. Peter Bogdanovich's 2001 film *The Cat's Meow* also focuses on the scandal. No charges were ever filed, and there was no investigation because Ince's own physician explained that his cause of death was heart failure.

In San Simeon and at Marion's beach house in Santa Monica, Charlie Chaplin and many others were frequent guests, and perhaps it is their residual spirits people have felt, seen and heard. Many have reported hearing laughter and voices of people talking. Music is heard, and then everything goes silent. Women have felt someone touch their shoulders or their derrieres.

415 PACIFIC COAST HIGHWAY

William Randolph Hearst and Marion Davies entertained lavishly at their Pacific Coast Highway beach estate in the late 1920s. W.R. collaborated with his architect, Julia Morgan, to build this opulent estate for Marion Davies. Included was a 118-room mansion, a marble swimming pool and a lovely guest house—all of this on five acres of prime Santa Monica oceanfront property. After having been sold and purchased a few times and serving as a hotel and private club in the mid-1990s, it languished in ruin. In 2005, philanthropist Wallis Annenberg, the daughter of media tycoon Walter Annenberg, pledged $27 million to restore the property and return it to some of its grandeur in order to turn it over as a public facility. The firm of Frederick Fisher and Partners was hired to restore what was left and design a new building. Included is a historic swimming pool and guesthouse, and this beach house contains a children's play area, a splash pad and volleyball and beach tennis courts. Almost everything is free, and it is open to the public.

It has been said that Marion Davies loved her beach house and that it was her favorite place to entertain her guests. She and William Randolph Hearst hosted numerous events and parties here. This hot spot on Santa Monica's coast included many of the Hollywood set as in San Simeon: Charlie Chaplin, Louis B. Mayer, Samuel Goldwyn, Greta Garbo, Clark Gable, Claudette Colbert and more. It is also claimed among the Hollywood luminaries that William Randolph Hearst and Marion Davies had a child together: Patricia Van Cleve. Marion always had claimed that Patricia was her niece, as she spent most of her time with Marion at San Simeon or elsewhere. Patricia married Arthur Lake and became Patricia Van Cleve Lake.

One evening, a couple were walking along the Santa Monica shore, as they had been invited to join another couple at the beach house before going to dinner that evening. They walked along the garden of the guest house and tried to imagine what it must have been like in the 1930s during one of Marion's famous parties. The sun hadn't set yet, and the ocean was beautiful, with the faint rhythm of the splashing waves in the distance. Then the couple heard music resonating out in the garden; it was coming from inside the guest house. As they approached the door, they peered through one of the windows of the living area and were greeted by the view of two figures dancing and laughing. The woman was wearing a shimmering, white, knee-length dress and strands of long beads. Her blonde curls swayed

with every twirl and Charleston jig. The man was not very tall, but his shock of dark hair was in full contrast to hers.

The couple observing from the outside, mesmerized as they were, wanted to join them. They found their way to the front door and walked inside. The music was louder, and they heard many voices coming from the various rooms announcing that a party was happening. The distinctive *clink* of glasses surrounded them, but there was no one there. They tip-toed to the living room and dining area, yet there was no one dancing. From above they heard voices, and the music stopped. On the staircase, two figures ascended to the second floor. It was the dancing couple, and their figures faded away in a white mist. Then they were gone—vanished to who knows where.

"They live here, and they must dance often," the lady remarked to her partner. "Yes, if only these walls could talk. The stories they could tell," she added.

Perhaps everyone is stuck in a time warp and they return regularly because their time at the beach house parties was not only fun and exciting but also a great time to be alive. Residual ghosts tend to remain at their favorite places.

THE GHOSTS OF THE PASO ROBLES INN AND JESSE JAMES

PASO ROBLES AND THE GHOSTS OF JESSE AND FRANK JAMES

Drury Woodson James and his brother, Robert James, came to California in 1849 during the gold rush. Robert James was Jesse and Frank's father. The James boys, Drury's nephews, did visit their Uncle Drury in 1868. The James boys were wanted for a bank robbery in Kentucky, so they decided they should head west to avoid capture.

By this time, Robert James had died. He passed away from an illness soon after he arrived in California and was dead in 1850. Drury got into the cattle business and made his fortune selling cattle to the miners and establishments. When Frank and Jesse arrived, they used Drury's ancient hot springs, and this helped Jesse to recover from two bullet wounds he incurred in a bank robbery in Gallatin, Missouri. (An aside about this, a lawyer, Henry Clay McDougal, sued the two brothers and won. Jesse James shot down John Sheets, cashier at the Daviess County Savings Association. When Frank and Jesse escaped, the citizens fired on them. Jesse was attempting to jump on his horse, but the horse bucked; Jesse fell, and his boot remained caught in the stirrup. Jesse whipped out his knife, cut the leather stirrup and freed himself as he was being fired upon. He leaped onto the back of Frank's horse, and they escaped.)

As Jesse recovered, Drury put him to work with his vaqueros to work with the cattle on the La Panza Rancho, which he owned. Of course, Drury

Paso Robles Inn and the turret for the widow's walk. *Courtesy of Laura Dickinson.*

was not thrilled at having the two boys visiting the family in California, and he attempted to keep them busy working or doing various chores around the rancho. Soon the two boys traveled to San Francisco and searched for their father's grave. They could not find it, for there had been a fire in the graveyard and all the wooden crosses and identifying markers were burned. Paso Robles became widely known due to the healing hot mineral springs in the area. From 1844 to 1864, there was the Hot Springs Hotel, which was owned by Drury James and the Blackburn brothers. This is where Jesse and Frank hid out, and they would escape scrutiny by escaping in the tunnels that ran under the hotel. In 1886, the railroad arrived, connecting Paso Robles to other hubs in California for travelers. The city of Paso Robles was incorporated in 1889.

In 1869, Drury and his partner, John Thompson, sold La Panza Rancho, and Drury moved his wife into the new community at Rancho Paso de Robles. The former adobe that Drury had built for his wife was also sold, and various tenants lived in the adobe until the interior of the adobe was destroyed by fire in 1890. Since then, many travelers along the road that lined both the old adobe ruins and the Old Oak Grove reported seeing shadowy horsemen that disappeared into the darkness of the woods, although there

would never be any tracks made by the horses. Often, witnesses heard wails and cries and voices speaking in an unknown language. The locals claim that the voices belong to the many Native Americans who congregated in the Old Oak Grove for their ceremonies and to celebrate their harvests. Shadow people are often seen in the area walking among the trees, only to disappear among the bushes and tall groves of trees.

The old adobe still stands on the La Panza Rancho, close to where Highway 58 borders the Carizzo Plains. Frank and Jesse spent one winter here when they visited their Uncle Drury. Their spectral apparitions are heard, and many have seen the two apparitions wearing their cowboy hats and riding their horses.

Today, there exists a phantom phone caller at the Paso Robles Inn, with the calls coming from room 1007. When the clerk picks up the phone at the front desk, there is nothing there. One night, the police received a 911 call from room 1007. When they arrived, the management at the inn had no explanation, as upon investigation, the room was empty. One has to hit "8" and "0" before calling 911. Staff then theorized that the caller was from the specter of J.H. Emsley, who discovered the fire at the Paso Robles Inn in 1940. He rushed downstairs and warned all the guests and staff to get out of the hotel. Emsley sounded the alarm about the fire at about 9:05

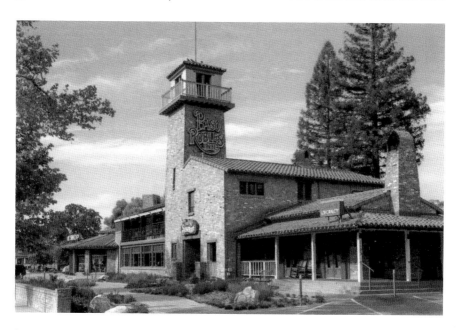

Paso Robles Inn. *Courtesy of Laura Dickinson.*

53

p.m., and the 911 call came closer to 9:30 p.m. The police explain that the Paso Robles Police Department receives a number of mysterious 911 calls from addresses that do not have a telephone. The telephone company investigated the line as well and found everything in working order. If it is Emsley's spirit, he spends his time trying to save the hotel guests and staff from the fire. He doesn't know that they escaped. As soon as he stepped outside that night in 1940, he had a massive heart attack and was declared dead after firemen arrived.

There are other unexplained events that have taken place at the inn. One cook is said to have quit when he witnessed a woman wandering in the garden and disappearing right in front of him. Guests and staff at the Paso Robles Inn talk about seeing a little girl in the ballroom that plays with marbles and her doll. Sometimes staff will be setting up for an event when something, or someone, lets go of a marble on the floor. No one else is there but those setting up for the event, and they are usually at the other end of the room. If you visit the Paso Robles Inn, take a look at room 1007—you may encounter a ghost.

THE RESTLESS SPIRITS OF VANDENBERG AIR FORCE BASE

ARE THERE HAUNTINGS AT VANDENBERG'S LAUNCH FACILITY A-05?

Everyone enjoys a good ghost story, from around the campfire out in the wilderness to a ghostly tale on late-night TV. Sometimes these tales are shared around the dinner table or just simply when curling up next to a warm fire with a collection of ghost stories in your favorite book. Do you dare read them if you are alone? Many brave souls do because they say that ghosts are not real—that they cannot possibly exist because human beings do not return from the dead. Right?

Tales circulate around Vandenberg Air Force Base about Malmstrom's haunted Launch Facility A-05. It happened in the early 1960s, when a security team was posted on A-05 due to a security issue. During the night, one of the security guards reported seeing an orb of bright light enter the premises. As the orb was floating and bouncing to and fro, the guard found his partner, and they both observed this orb of white light. It transformed into a Native American maiden in full attire. She was wearing silver and many beads. The two were transfixed yet deeply frightened. The mist dissipated and took off as an orb once again before disappearing.

The next night, a second security team assigned to A-05 observed two orbs making their way inside the facility. The bright lights found their way toward them, and when they touched the ground, they became two different

people. The Native American maiden stood on the left, and a Native American chief, dressed in a full feathered headdress, stood beside her. His headdress was so long it reached the floor. The security team was shocked and terrified. The two apparitions then vanished. The community attributes the hauntings by the Native Americans to the launch facility being built over a Native American burial ground.

APPARITIONS BY THE SEA AND THE HAUNTED LIGHTHOUSES

ANACAPA ISLAND'S SIREN SONG

If you enjoy the sea and have ventured out on a fishing boat, taken a cruise or served in the United States Navy aboard a commanding aircraft carrier, you know how beautiful the sea is during the day. During moonlit nights, the sheet of glass reflects the night sky, and one can admire the beauty of the night. The sea is magic, and it beckons you to explore more, as the legend of the siren song in Homer's *Odyssey* represents the forbidden. Many have taken their boats to Anacapa Island and had uneventful trips— they fished, went scuba diving or took out their kayaks in order to get up close to the many sea lions and harbor seals in the magnificent Channel Islands National Park. Their survival depends on the kelp forest ecosystem for their habitat. Boats have run aground here and accidents have occurred on the open sea near the island, resulting in many shipwrecks. The word *Anacapa* is from the Chumash language and means "mirage" or "deception" The island itself seems to change its form from a long, thin strip to a large, massive appearance depending on how much fog is surrounding it. Anacapa is part of the Channel Islands, and it is known as the Channel Islands National Park.

One park ranger used to live on Anacapa Island in the lighthouse residence. He and others heard someone, or something, pacing back and forth in the attic. The ranger was alone. After mustering up the courage to

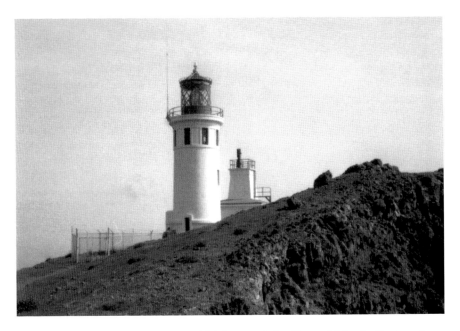

A view of the Anacapa Lighthouse, which is part of the Channel Islands. *Courtesy of Laura Dickinson.*

see who else was in the lighthouse, he opened the attic door and his flashlight flooded the darkness. He ran it all around the room and up and down the walls. Empty. This happens frequently.

Other instances of weirdness include when something opens the heavy door and slams it shut. It can get spooky when this occurs at night or during the wee hours of the morning. Being alone on this island, surrounded by the splashing waves, can be nerve-wracking to say the least. It is not for the faint of heart.

On January 31, 2000, Alaska Airlines Flight 261 crashed into the Pacific Ocean two miles from the Anacapa Lighthouse. According to news reports, the park ranger at that time witnessed the plane fall into the sea. Describing the scene, he remarked how eerie it was because everything was silent when the plane hit the water. Time stood still. Search and recovery efforts began immediately, and one family in Ventura watched the divers and the rescue boats on the ocean that night. The huge lights they used illuminated the Pacific waters as the Coast Guard and divers worked through the night. It was calm and peaceful, and yet there was death and destruction on the open sea that night. From their hillside home, the family had a unique view through their telescope and binoculars.

Several years later, a Coast Guardsman lost his life on Anacapa Island. He fell from a dock ladder one uses to climb up to the island itself. He fell, hit his head and suffered severe injuries. After being airlifted to a local hospital, he passed away a few hours later. The dock ladder is made of steel and it is very secure, but accidents do happen; if one has slippery shoes, one can easily slip.

Ghosts and apparitions have been seen standing on the cliffs overlooking the sea. Voices have been heard. When the wind howls at night, it becomes an eerie place. Over the years, many have perished in the restless waters surrounding Anacapa Island, from sailors to fishermen and divers. There are those who lost their lives in other accidents as well. Beware of the island's siren song—it's beautiful and beckoning and quite foreboding after dark.

CENTRAL COAST LIGHTHOUSES

Along the Central Coast there are a few other lighthouses that would interest you. There is the Point San Luis Lighthouse near Ávila Beach, the Piedras Blancas Lighthouse near San Simeon, the Point Pinos Lighthouse in Pacific Grove and the Point Sur Lighthouse. The latter is considered the most haunted lighthouse along California's coastline. In 1889, the Point Sur Lighthouse was completed, and the lighthouse keeper set up residence there. In those days, the lighthouse was manned twenty-four hours a day so the ships coming in could always visualize the coastline and hopefully lead to fewer shipwrecks or loss of life. The lighthouse keepers had several assistants to help with the lighting tasks. Later, the United States Coast Guard implemented automatic lights, and the last keeper officially left Point Sur in 1974.

People assume that the spirits of shipwrecked sailors who lost their lives along the coastline of the lighthouses haunt these places. Many drowned in the sea or suffered accidents associated with shipwrecks or boating, and some were even savagely murdered. Visitors have seen the ghost of a little girl at Point Sur. She is playful and happy, and she plays inside as well as outside the lighthouse. Her disembodied voice has also been heard as she speaks to some, and she also laughs with those she is talking to at this lighthouse. Others have seen the apparitions of several people.

HAUNTED POINT SUR LIGHT STATION

Many claim that the Point Sur Light Station in Big Sur is haunted by the trapped spirits of sailors who perished in the shipwrecks along the coast. Others have seen a ghost as he climbs the stairs or walks along the grounds of the light station. He is known to vanish before your eyes. Laughter and voices are also heard here, particularly that of a little girl. There are those who claim to have seen the child and spoken to her. She is friendly and sweet—then, to their amazement, she disappears. She looks like a real person and not a ghost, so it's quite disturbing when she vanishes into thin air in the middle of a conversation. It is a hauntingly beautiful location, and the spirits will welcome you if you decide to visit them. This historic lighthouse was built in 1889. The spirits are known to whisper, and you can hear their muffled voices.

Some claim that they have identified as many as twelve active spirits at the Point Sur Light Station inside the residence. One man likes to sit and read a newspaper in the sitting area, only to vanish when he is noticed. A woman has been seen walking outside, and on occasion she asks for directions. She has been known to mingle with the visitors and vanishes before their very eyes. Several ghost hunters have claimed that Point Sur Lighthouse is very active with spirits. Some of these spirits claim to "live" at the lighthouse—one can assume that they lived at the lighthouse when they were alive. Others have claimed to have seen and felt the grip of the dead sailor who haunts the residence of the Point Sur Lighthouse. Many nonbelievers and skeptics of the supernatural become instant believers upon meeting the dead sailor. Here is one account of what occurred one evening.

The members of a lively group of tourists were saying their farewells and gathering their cameras and bags when a tall gentleman seemed to be searching for one of his items. Having searched everywhere, he resorted to searching under the cushions and behind the pieces of furniture. Perhaps he had laid down his camera somewhere or, worse yet, someone picked it up by mistake. He was about to give up when he suddenly felt very cold. That was odd because it was in the middle of summer. Nevertheless, he was cold, and he knew that his friends were waiting for him outside, so he started for the door. He heard a voice behind him, "Is this yours?" He swung around and caught a glimpse of his camera falling from midair onto the couch, as though someone had just tossed it. The man was terrified because he did not see anyone there. He snatched his camera and made a beeline to the door. Suddenly, he felt

something touch his shoulder. It was a heavy hand that slowed him down so much he nearly fell.

Regaining his footing, he dared not look back, but he was out of there. Running to where his friends were, they noticed that he was out of breath and could barely speak. One woman remarked, "Fred, are you all right? What happened in there?"

Fred was shivering, and his friend who was a physician wrapped him up with another jacket and explained that Fred was going into shock. They walked him to the car and sat with him until he calmed down. They finally found their way back to their hotel for dinner, during which Fred told his tale. He held up the camera for all to see, as it was the item the ghost had touched. Fred suddenly felt faint and made up his mind never to touch that camera again. He began the trip as a skeptic and returned home to San Diego as a believer. His friends say that his camera is inside a locked box with a letter of warning attached for whoever discovers the box after Fred is gone from this world.

POINT PINOS AND THE APPARITION OF EMILY FISH

Built in 1855, the Point Pinos Lighthouse is located on the northern point of the Peninsula in Pacific Grove. It used whale oil to fuel the light, and in 1880, it switched to kerosene. Electricity was installed and used to replace the oils in 1919. It is the oldest operating lighthouse on the West Coast and is in the National Register of Historic Places. Point Pinos Lighthouse still contains the original lenses and prisms, which are still actively used for navigation.

Point Pinos Lighthouse has been described as being very haunted. In the early days, this lighthouse was a social hub for the townspeople. When Emily Fish took over as lightkeeper in 1893, she hosted many parties and gatherings at the lighthouse. She was widowed at age forty-eight and was fifty when she took the post. Emily Fish was well liked by the community and was serving as lightkeeper when the 1906 earthquake took place. The tower had to be reinforced after the earthquake, and the lens had to be sent out for repair. Emily retired in 1914 and moved to the town of Pacific Grove, where she remained until her death.

When you visit the lighthouse, you may see Emily's apparition wandering the rooms on the second floor of the residence. One can hear the rustling of her long skirts and petticoats as she walks the hallway, and a scent of

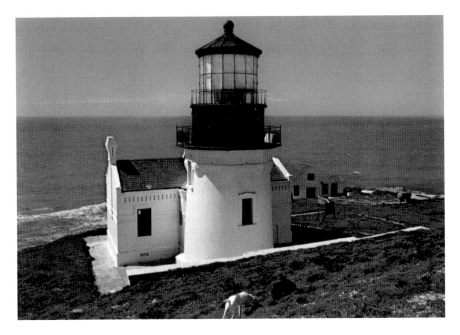

This is the well-known Point Conception Lightstation. *Courtesy of Laura Dickinson.*

her perfume leaves an invisible trail behind. When you enter her bedroom, you can easily feel her presence. If you pick up an object and move it, it will be returned to its original spot before you are aware of it. Objects have been seen moving on their own; some items, such as her hairbrush, were noticed suspended in midair and then set down quietly as though she were actually brushing her hair. Two witnesses saw this and freaked out. They left the lighthouse and never returned. Emily's teenage daughter died at the lighthouse in 1900 of tuberculosis, and her apparition has been seen upstairs as well. Late in the evenings, one can hear voices trailing from upstairs and sometimes hear a slight coughing sound. Music emanates throughout the house on occasion as Emily enjoys the parties she hosted for all her guests.

One visitor commented on how festive the lighthouse seems to be. The character of Point Pinos Lighthouse gives one the feeling of good vibes and positive energy. If you are a skeptic, be prepared to be pleasantly surprised.

MORE ABOUT THE LIGHTHOUSE AND POINT SUR LIGHT STATION

Pacific Grove has the Point Pinos Lighthouse, where the ghost of Emily Fish is frequently seen. She is known as the "socialite light keeper." A lighthouse is a tower with a bright beacon that is used by the sailors at sea to navigate their way to shore, whereas a light station contains the lighthouse complex, which usually includes the light keeper's house, a boathouse, a fuel storage shed and buildings located on the light station grounds. In Monterey County, Point Sur Light Station is a National Historic Landmark and is the only station open to the public. Point Sur Light Station houses many spirits and ghosts. It was built in 1889, and the light station keeper's daughter passed away there from tuberculosis; she still haunts the light station. She frequents the grounds and has been seen walking about and also inside the light station. Point Sur Light Station is listed on "America's Top 10 Most Haunted Light Stations," and many consider it the most haunted light station in the United States.

The Spirits of the Adelaida Cemetery and Día de Los Muertos

The Haunting at Adelaida Cemetery

Over the years, there have been many curiosity seekers venturing into the Adelaida Cemetery graveyard. It's safer to visit during the day, when one is not trespassing and you can see what's in front of you or behind you. There are those brave souls who have dared wander into Adelaida after midnight. This is what they saw. Four high school boys had gone out to a party with their friends earlier in the evening when a girl at the party was asking questions about Adelaida Cemetery. She claimed that it is haunted by a lady in pink and that her mother saw this ghost twenty years earlier when she visited the same cemetery late at night with a group of friends. This group of four high school seniors made up their minds to stop at the cemetery on their way home. After saying goodnight to the party hostess, they took off in one car. They drove along Chimney Rock Road and arrived at the cemetery.

They left their car outside the iron gate and walked around to the side with only their flashlights. They were here to see if they would see the ghost of Charlotte Sitton. She is known as the Pink Lady, and she has been seen walking among the gravestones. Charlotte was despondent after the death of her child, who is buried at the cemetery, and she took her own life in 1890.

This group of four related what happened next. When they were taking photographs, an apparition rose up as a white mist, and they could see the

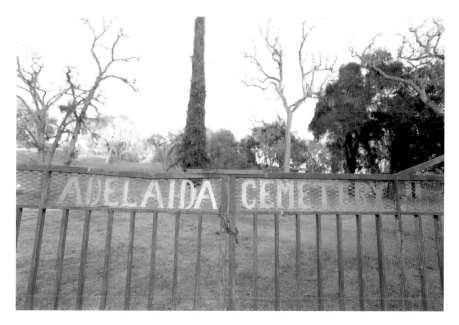

A view of the Adelaida Cemetery in Paso Robles. *Courtesy of Laura Dickinson.*

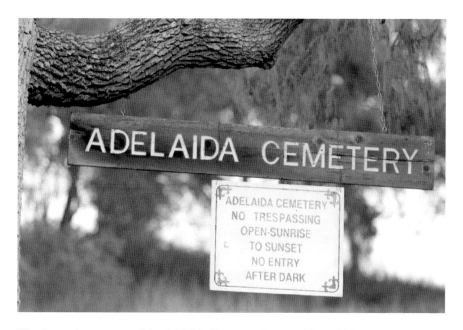

The sign at the entrance of the Adelaida Cemetery. *Courtesy of Laura Dickinson.*

Left: Here is a grave marker with toy horses, which means it was probably a child's grave. *Courtesy of Laura Dickinson.*

Below: A view of the grave markers at Adelaida Cemetery. *Courtesy of Laura Dickinson.*

shape of a woman in a long dress slowly approach them. Suddenly, fog rose up and enveloped them as well, and their fear reached a fever pitch as they sprinted toward their car. In front of them stood a woman dressed in pink, blocking their exit through the gate. It was cold, and the gray mist was everywhere. She stepped toward them and screamed, "Get outttttttt!" And with that, they ran around her and dashed out of the gate. Her eyes followed them as they climbed into the car; once inside, they watched her apparition float in the opposite direction. As the driver turned on the ignition, nothing happened. No sound, nothing. The battery seemed dead. The Pink Lady disappeared into the blackness. The young man turned the ignition, and the car finally started. They left the cemetery, never to return. They saw what they wanted to see at Adelaida Cemetery. Be careful what you wish for.

They each remember that night, and they know what they saw. Strange things happen at Adelaida Cemetery at night. If the spirits are out walking around, your car may not start right away since the spirits need energy and may be responsible for draining your battery. Others have reported their keys missing or hearing voices behind them as they walked throughout the cemetery grounds. Be aware of these apparitions and the mischief they might resort to during your visit.

DÍA DE LOS MUERTOS

The historical roots of this holiday date back more than three thousand years, as it is an important day on which the people of Mexico honor their dead. It was important to the Náhuatl people, which includes the Aztecs and Mayans. When Hernán Cortés and his men conquered the Aztec empire, this custom of honoring the dead survived to the present. Día de los Muertos is celebrated on November 1 and November 2, corresponding to the Catholic calendar of All Saints' Day and All Souls' Day. It has gained popularity in the southwestern United States, and the traditional altars are set up in many homes where photos of family or friends who have passed on are honored. Included are the *calacas*, or skeletons, and the *calaveras*, the skulls. This is the day when families pay tribute to those who have passed on, and it is believed that for one day, the dead awake from their eternal sleep and join their living relatives or friends in celebration. Mexican people believe that little angel spirits come to earth on October

31 at midnight and stay for twenty-four hours. Then the adults come the following day and remain on earth until November 2.

Families take sweet bread, sweet pumpkin candy, chocolate, alcoholic mescal, *pulque* and *atole* to the local cemeteries, where they share their offerings and share stories of those who have passed on. These foods are also placed on the home altar, as not every family goes to the cemetery to celebrate. Spirits walk freely among the living and at times are seen by family members, or perhaps a message will be delivered from beyond the grave.

One family shared their experience about what happened to them during a Día de los Muertos celebration. They were preparing all the *calaveras*, and the children painted them. They had fun decorating them because they were going to be placed on the home altar next to their grandpa's photos. One of the children was taken ill with a bad cold that turned into bronchitis. Her mother told her that she had to remain in her room so as not to pass her bad cough to the family members. As she lay in bed, she listened to the singing and the music that was coming in from the outside. She recognized her brother's voice and her sister's guitar. Suddenly, the room glowed as though someone had turned on ten light bulbs. She had to close her eyes it was so bright. Then she felt a very gentle touch on her

Oak Hill Cemetery in Ballard, California. *Courtesy of Laura Dickinson.*

Oak Hill Cemetery. *Courtesy of Laura Dickinson.*

shoulder, and immediately a very relaxing sensation ran through her body. All the pain from her cough was gone. She let go of everything and was overtaken by the need to sleep. The light no longer blinded her. She closed her eyes and saw nothing.

Several hours passed, and her mother was soon whispering in her ear to wake up, for it was time for her medicine. She remembered sitting up, and her mother remarked how healthy she seemed to be, as her fever and cough were gone! To explain this, her daughter relayed the story of the blinding bright light, how she felt a soothing touch on her shoulder and how sleep was the only thing she could do. She was helpless to do anything else since all her muscles relaxed. As her mother was a wise woman, she and her daughter started to pray, and afterward, she explained that it was the little girl's grandfather who had come to visit her. The family believes it to this day and always remembers their *abuelito* at each Día de los Muertos celebration.

THE LEGENDARY EDIE SEDGWICK

After Edie Sedgwick's death, her mother had her buried at the Oak Hill Cemetery in the small community of Ballard, which is near Solvang. Edie was beautiful, high-spirited and very individualistic. She was a fashion icon in the 1960s, when she lived in New York. She modeled for *Vogue* for a short period of time, but then Edie started taking drugs and drinking heavily. Andy Warhol made her the queen of his films, and she frequented Warhol's Factory along with Truman Capote. It was during this period that she met Bob Dylan, and it is rumored that she was his inspiration for some of the songs on his 1966 album *Blonde on Blonde*.

It is well-known that Edie Sedgwick had an immediate attraction to Bob Dylan when she met him during a chance encounter at Andy Warhol's Factory in New York City in 1965. They flirted with each other rather outrageously, and it was very obvious to all that there was an attraction there. By the end of 1965, Edie was made aware that Bob Dylan had married Sara Lowndes in a secret ceremony. In spite of his marriage, many have speculated that Dylan's hits "Leopard-Skin Pill-Box Hat," "Just Like a Woman" and "Like

Edie Sedgwick's grave marker at the Oak Hill Cemetery. Her mother, Alice de Forrest Sedgwick, is buried alongside her. *Courtesy of Laura Dickinson.*

a Rolling Stone" were all about Edie, as she influenced him and became his muse. Then Edie moved on to have an affair with folk musician Bobby Neuwirth, who was also Dylan's good friend. Edie was no longer in Warhol's inner circle, and of the last film they made together, *Lupe*, Warhol told a writer that he wanted something where Edie commits suicide at the end of the film. This is eerie because Edie's final real-life exit was an overdose of barbiturates in 1971. Dylan was also a regular at Warhol's Factory.

Edie faced many issues in her life, including her drug addiction and mental illness. She married a man she had met in the hospital where she was born in Santa Barbara, California. She took an overdose of barbiturates, and her husband found her dead the next morning. Edie's mother passed away twenty years after Edie and requested to be buried next to her daughter.

THE WHITE LADY OF SANTA MARIA

At the intersection of West Foster Road and South Blosser Road, a ghostly lady dressed in white has been seen walking along the roadway. She has also been seen wandering the grounds of nearby Pioneer Park. Legend has it that this woman was murdered and her body buried among the eucalyptus trees growing there. A mother and her daughter were driving through the intersection one night when they saw a woman walking along the road. As their car approached her, she suddenly vanished into thin air. Others have had similar experiences along the two roads.

One night, Mary and John were walking through Pioneer Park, arm in arm, sharing their hopes and dreams with each other. They were so happy, laughing and enjoying being together. Mary and John were preparing to graduate from high school and move away to attend college. John would be playing basketball at a school in the Midwest, and Mary was moving to Northern California to pursue her education. Suddenly, the wind whipped up, and Mary started feeling so cold. John took off his letterman's jacket and wrapped it around her. As he did so, their attention was drawn to the shrubbery about ten feet in front of them. A white light started rising from the ground, illuminating the bushes and the eucalyptus trees nearby. The light was a white mist that formed into the shape of a long cloak, and a woman was wearing the cloak. She unleashed a wail that sent chills up and down their spines. She turned to look at the pair, and John and Mary saw her bony face with empty eye sockets.

He pulled Mary and told her to run. He let go of her hand, and both ran toward the edge of the park, where they had left the car. They ran as they had never run before. Their adrenaline rush saved them from this ghost. John locked the doors as soon as Mary was safe in the passenger seat and attempted to start the car, but it would not start. The White Lady was standing at the edge of Pioneer Park, as though she were watching them. She turned around and disappeared. At that moment, the car started, and John peeled away from that ghostly place. They were terrified. They realized that they had seen the ghost everyone talked about, and they decided they would never mention it to anyone. They left and never returned to Pioneer Park.

A businessman was traveling along West Foster Road when he saw a woman standing at the intersection. She was leaning against the eucalyptus tree next to the road. When the light beams from the headlights shined on the tree, the woman was gone. He thought nothing of it, so he turned around to continue his journey. As he fumbled with the radio, he glanced into his rear-view mirror. There, sitting in the back seat, was the White Lady. The white mist resembled the look of smoke, but it was a mist; it was wet and had the smell of mud and river water. It filled the back seat of the car, and it was beginning to cover him. It touched his hair and neck and then his arms, and he could barely see the road for all that mist. As an expert driver, he maneuvered the car to the side of the road and powered down all the windows. When he looked into the back seat, no one was there. The goosebumps mixed with his fear were a recipe for disaster. He rolled up the windows and sped away. He never looked back and stayed clear of that road at night.

JACK SWANN AND THE
GHOSTS OF THE FIRST THEATRE

JACK SWANN

In 1846, Jack Swann built California's First Theatre from the lumber he salvaged from a shipwreck in Monterey, California. First Theatre is now a part of the Monterey State Park System, and it is reportedly haunted by Jack Swann himself. Jack added a stage and benches in 1850 and new whale oil lamps for lighting. A group known as Colonel Stevenson's 1st New York Volunteers performed in the theater, and it is recorded that tickets sold for $5 each. One of the plays performed here in 1848 was *The Putnam or the Lion Son of '76*, and according to the record, Swann collected more than $500 for one night's performance. Melodramas were very popular during this period. There was a small orchestra that played during the performances, and just as in today's films, the music highlighted action on the stage, from a character's suspense to romance. Jack profited from several business ventures, and he had a small adobe built where he set up his residence next to the theater. In 1896, Jack passed away, and his death left the theater and adobe vacant.

In 1906, a small group from Monterey purchased the building and the old adobe. It was assisted by funds from the W.R. Hearst's California Historic Landmark League, and it deeded the building to the State of California. California's First Theatre was opened as a museum in 1920 after having

California First Theatre in Monterey, California. *Courtesy of Laura Dickinson.*

been restored. In 1937, the buildings were leased to a company of troupers that revived the nineteenth-century melodramas and held performances there until 1999.

LOLA MONTEZ AND MONTEREY

Born on February 17, 1818, in Ireland, Lola's birth name was Eliza Rosanna Gilbert. Although she had an independent streak, she was dependent on wealthy men for her livelihood. She eloped at sixteen to marry Lieutenant Thomas James, but they separated five years later and Lola began a career as a Spanish dancer. However, a scandal erupted when she was recognized as Mrs. James. She traveled to Europe, where she performed her dancing. Lola was well known for her dark, exotic eyes and hair, as well as her lively temper. She became a famous courtesan, accepting favors from wealthy men, and she was a mistress to Franz Liszt and, at age twenty-five, the mistress of Ludwig I of Bavaria. Ludwig adored her and made her the Countess of Landsfeldt and gave her an annuity. She sailed to America and performed her "Spider Dance" on the East Coast, as well as in San Francisco and many

California Gold Rush mining towns. She attached rubber tarantulas to her already risqué, short skirt (it was just at the knee), and she danced. The miners would throw gold nuggets to her on stage to signify their approval. She married Patrick Hull, a newspaperman, and they traveled to Monterey and a few other places to spend their honeymoon. It was then that she may have danced at the First Theatre in Monterey. Her marriage did not last, and she settled in Grass Valley. Lola returned to New York in 1857. She fell ill with pneumonia and passed away at the age of forty-two.

Jack Swann would have definitely wanted Lola to perform during her short time in Monterey, as in many of Lola's performances, gentlemen and miners were paying ten dollars per ticket as admission to her performances. Perhaps it is her voice one hears emanating from the First Theatre, and the footsteps one hears could be her dancing shoes. Jack Swann has been seen standing up on the second-floor railing looking down and watching the crowd. Perhaps Lola Montez will materialize someday in all her glamour and beauty.

CUESTA COLLEGE INTERACT THEATER

The two ghosts that haunted the Cuesta College Interact Theater caused havoc until the 1980s, when an exorcism was held that eliminated the spirits. What happens at the theater these days is that lights turn on and off, and objects are moved. The actors and stage directors do not feel threatened, as they regard the ghostly activity as a mere nuisance. They are not frightened. As one person explained it, the ghosts are playful and just want to be noticed. Originally, a married couple lived near the theater, but the husband killed the wife. The legend states that these are two ghosts that used to haunt the theater. After the exorcism, they left the theater.

THE CABIN, ORSON WELLES, RITA HAYWORTH AND THE NEPENTHE RESTAURANT

When Orson Welles and Rita Hayworth married on September 7, 1943, they were young—she was twenty-five and he was twenty-eight. He had already reached the pinnacle of his success with his radio play *The War of*

the Worlds, broadcast in 1938, and the classic film *Citizen Kane*, which was released in 1941 when he was twenty-three.

Orson and Rita were selling war bonds for the U.S. government in San Francisco sometime during the war, and after the event, they decided to take the new Highway 1 down the coast on their return trip to Los Angeles. They pulled off the highway and traveled up a dirt road to the top of a hill. From this vantage point, they had the most beautiful view of the Central Coast. There was a cabin there, and they stopped there to eat and admire the view. They found a realtor and offered to buy the cabin. Both decided it would be their vacation hideaway from their busy life in Hollywood. It has been recorded that Rita measured the windows for curtains, and Orson said that he would get pipe laid in the kitchen for gas. They came up with $167 for a down payment. They never returned to enjoy their cabin, and it was sold in 1947.

Bill and Madelaine "Lolly" Fassett built a restaurant, the Nepenthe, around that cabin. The Fassetts purchased the cabin and the surrounding land from the two stars in 1947 for $22,000. It is quite well known in the Big Sur area. It is twenty-nine miles south of Carmel, California.

Before the cabin was sold to Orson and Rita, it was rented to a writer, Lynda Sargent, in 1940. She invited Henry Miller, another writer, to stay with her until he found a place of his own. Henry Miller was a frequent guest of Ed "Doc" Ricketts at his laboratory on Cannery Row in Monterey.

Nepenthe is the name of a drug or drink, described in Homer's *Odyssey* as having the power to cause forgetfulness of sorrow or trouble. It is referred to anything that induces a sensation of forgetfulness. It is a fictional medicine, an antidepressant type, mentioned by ancient writers in Greek literature and mythology. It is claimed to have originated in Egypt.

Two apparitions have been seen overlooking the scenic view of the sea in the distance from the surrounding area near the Nepenthe restaurant. The restaurant was opened on April 24, 1949, and it was one of Henry Miller's favorite places. Artists, poets, writers and other creative types frequented the restaurant, such as Anaïs Nin, Ernest Hemingway, Eric Barker and actor Clint Eastwood, among others.

Many who visit the Nepenthe talk about how beautiful everything is and how they sense the positive energy and good vibes of the area. It seems that many still return to it and never want to leave.

ORSON WELLES'S FIRST CHILD REMEMBERS VISITS TO HEARST CASTLE

Chris Welles recalls many memories of her childhood and growing up. Chris's mom, Virginia Nicolson, and Orson Welles divorced. Virginia's second husband was screenwriter Charles Lederer. He wrote or co-wrote such notable works as *Gentlemen Prefer Blondes* in 1953, *Ocean's 11* in 1960 and *Mutiny on the Bounty* in 1962. Charles and his sister, Pepi, were raised mainly by their aunt, Marion Davies, who was William Randolph Hearst's mistress for more than thirty years. They lived at the main house in San Simeon. Hearst asked Charles Lederer to find him an attorney so that a trust agreement could be added to William Randolph Hearst's will. This trust would provide for Marion Davies with a lifetime income from the Hearst estate. There is also some discussion that Marion's niece, Pepi, is actually the child William and Marion had together.

When Chris and her mother, Virginia Nicolson, and stepfather, Charles Lederer, would visit San Simeon, her parents would be escorted to a guest villa, but Chris and her nanny would be banished to "the tower" and were always isolated. Marion did not want W.R. Hearst to get angry upon seeing Orson Welles's daughter at San Simeon. He disliked *Citizen Kane*, as he thought it was all about him, and he disliked Orson Welles even more.

LATE AT NIGHT

Many of the California park rangers who work at Hearst Castle as caretakers and tour guides have been reluctant to share their experiences at the Castle because they cannot explain the disembodied voices or the mists that wind their way up and down the staircases. There are reports of hearing sounds of splashing water in the indoor pool when no one is around. At other times, one distinctly hears the sounds of music. The song "Moonlight Serenade" by Glenn Miller is frequently heard inside the main house.

Other nights, caretakers have heard the distant sounds of laughter, dancing feet and music playing, such as Charleston music. When they turn on the lights, the music stops and the room is silent and empty. Several visitors have shared how an invisible someone put his or her hand on a guest's derriere.

Today, the Hearst family still uses the landing strip on the Hearst Castle estate as William Randolph Hearst used it for his many guests. If one has

heard the voices or felt the invisible hand touching their arm or shoulder, it could very well be one of the famous guests still residing within the walls. One caretaker admitted that when he would make the rounds at night with his dog, the dog refused to go along the back side of one of the buildings. The Rottweiler pulled his ears back, growled, barked and refused to move. The caretaker made an about face and did not investigate why his dog reacted as he did. He trusted him to know there were probably spirits out there that cannot be explained. This occurred every time they went walking along the property, whether at dusk or in the dead of night. It is reasonable to think that the spirits continue to celebrate with dance and music, as they did when William and Marion were alive. When you visit Hearst Castle, you may be lucky enough to meet one of these spirits.

The Resident Ghost of the Robert Louis Stevenson House and the Spirits of Cannery Row

Haunted Monterey and the Robert Louis Stevenson House

Robert Louis Stevenson stayed at what is known today as the Stevenson House Museum. It was a boardinghouse when R.L. Stevenson stayed at the house in the autumn of 1879. Manuela Giradin owned the establishment, and her husband died of typhoid fever in 1879. Then her two grandchildren came down with the same disease. Manuela cared for the children until she contracted typhoid fever herself. She was exhausted caring for them, and having lost her husband as well, it must have been a very difficult time for her. Her grandchildren survived, but she passed away from the disease on December 21, 1879. Her apparition has been seen on the second floor as she goes about her daily tasks. She is wearing a long black dress with a high lace collar. When you enter the upstairs nursery, you may see her sitting on one of the beds, or she may be standing by the window. Visitors have reported seeing the nursery rocking chair rocking by itself as if a child were sitting in it. One also gets a whiff of carbolic acid in the room, as it was used as a disinfectant in the 1800s.

This historic two-story adobe has hosted politicians, artists, writers, fishermen and families. During the Mexican era, it had many visitors. When it was a rooming house, it was known as the French Hotel. When Stevenson stayed there, he was in poor health and was cared for by his friends. During this time, he also courted his future wife, Fanny Osbourne. The tale of

Robert Louis Stevenson House in Monterey, California. It is now a museum, and the docents give tours to visitors. *Courtesy of Laura Dickinson.*

Treasure Island, many claim, is based on Point Lobos, while others say it is based on Norman Island in the British Virgin Islands. The rocky coast found in his native Scotland serves as another theory. Many accounts tell about Stevenson's numerous walks along the Monterey seashore and through the Monterey pines. He remained in Monterey from August 30 to December 22, 1879. According to the dates, he left Monterey the day after Manuela Giradin passed away. His writings about Monterey were published in 1880 under the title "The Old Pacific Capital," and he successfully published *Treasure Island* in 1881. In 1886, *Kidnapped* and *The Strange Case of Dr. Jekyll and Mr. Hyde* were published. Robert married Fanny on May 19, 1880, and he passed away on December 3, 1894 in Samoa. He was stepfather to Fanny's two children from her previous marriage, Isobel Osbourne and Samuel Lloyd Osbourne.

After Robert L. Stevenson's death, Fanny traveled and took residence in San Francisco. She moved to Montecito and lived in a lovely haunted house on Hot Springs Road. The home was known as the Stonehedge House, and it is where the previous owner, Countess Ritter, took her own life in the upstairs bedroom. Today, much of the properties along Hot Springs Road

Robert Louis Stevenson House, front view. *Courtesy of Laura Dickinson.*

The luscious garden at the Robert Louis Stevenson House. *Courtesy of Laura Dickinson.*

The plaque commemorating Robert Louis Stevenson. *Courtesy of Laura Dickinson.*

have been devastated or destroyed by the Montecito mudslides and debris flow, which occurred in January 2018. Twenty-three people lost their lives in the early morning hours, when massive boulders and mud ripped people from their beds as they slept.

The Ghosts of Cannery Row

You will be greeted by the relics of a time long past when you visit Cannery Row. John Steinbeck memorialized the sardine factories and the style of life during the 1940s in his book *Cannery Row*. It was previously called Ocean Avenue, but in 1958, the name was changed to Cannery Row in honor of the book. The Pacific Biological Laboratories was owned by Ed Ricketts, a marine biologist and John Steinbeck's best friend. "Doc Ricketts" was what he was known by, and he sold preserved animals and microscopic slides of many maritime aquatic species. He was way ahead of his time, as he was also an ecologist. His book *Between Pacific Tides* was published in 1939, a pioneering study of intertidal ecology. He also collaborated with

A view of Cannery Row in Monterey. *Courtesy of Laura Dickinson.*

Another view of Cannery Row, where John Steinbeck and Edward "Doc" Ricketts would get together. The writer Henry Miller was a friend as well. *Courtesy of Laura Dickinson.*

Above: A landmark brick building along Cannery Row. *Courtesy of Laura Dickinson.*

Left: The famous street sign of Cannery Row. *Courtesy of Laura Dickinson.*

John Steinbeck on *The Sea of Cortez*, which was later republished as *The Log from the Sea of Cortez*. Doc Ricketts described sardine ecology, the harvests and habitats. Although he did not have a university degree, he analyzed sardine fishery and wrote copious notes about his ecological observations. Doc Ricketts's work is still referenced in journals and other books today. Artists, writers, scientists and others frequented his lab. The author Henry Miller was a friend, as was the mythologist Joseph Campbell.

In 1948, Ricketts and Steinbeck planned another expedition to go to British Columbia and write another book. On May 8, 1948, Ricketts was driving across the railroad tracks at Drake Avenue, which is a short distance

from Cannery Row, when a passenger train hit his car. He lived for three days but succumbed to his injuries on May 11. A life-size bust of Ricketts is at the site of where the accident took place.

Doc Ricketts is still in Cannery Row, and he has been seen inside of his lab. Eerie lights turn on and off by themselves, and there are unexplained noises and sounds that come from inside the laboratory. Objects move by themselves and are found scattered inside the laboratory, as if someone forgot to put things back after using them.

Perhaps he still visits his lab because there is so much unfinished business he has to complete.

MONTEREY BAY AQUARIUM

One family's story about the Monterey Bay Aquarium dates back to the early 1990s. While vacationing in Monterey, the parents took their three children to visit the aquarium. The two boys, ages seven and nine, followed their father, and the daughter walked around with her mom. After twenty minutes, mother and daughter were admiring the beautiful sight of the frolicking and swimming fish in the circular aquarium. They were mystified and mesmerized by the sight of nature's beautiful creatures swimming about as though hamming it up for the cameras. Suddenly, the father came rushing into the area when he noticed his wife, Mary, holding their daughter Kathy's hand as they both leaned against the glass. Anthony was agitated, as he could not find the boys. "They must have wandered off and now I cannot find them anywhere. I hate to interrupt your viewing pleasure, but why don't you two go and wait by the entrance and let someone know our boys are 'missing' somewhere in this Aquarium."

Mary thought this was a good plan. The family always stuck to a plan that if someone were lost, it would be a good idea to just go back to the main entrance of a venue, park or concert and a family member would go there first and wait for them. This would be better than wandering around needlessly, as the Monterey Bay Aquarium was crowded that day, and there were many visitors. After two hours, there was still no sight of Adam and Anthony Jr. Mary and Kathy were anxiously looking for them through the sea of faces yet found nothing. When Mary was about to give up hope, here came Anthony with their two sons. Mary was delighted to be reunited with them. The boys were smiling and happy, and they shared that a very nice

man took them around the aquarium and told them all about the fish and other sea creatures. Anthony Jr. explained that they were able to go outside and look at the creatures in the tide pools. After the family's second tour of the Monterey Bay Aquarium, they passed through a photo gallery, where some of Cannery Row's notables were featured. Immediately, Adam and Anthony Jr. pointed to a print on the wall. Anthony Jr. excitedly remarked, "There's Doc. He's the man who took us around and showed us all the fish. He was fun and nice, and we had a good time. We weren't lost at all. We had the best time, and we got a real tour!"

Anthony, Mary and Kathy tell this story often, as they believed the boys were telling the truth. Had "Doc" Ricketts returned to give them a guided tour? Does he frequent the Monterey Bay Aquarium? He has been seen there many times, as well as strolling down the street of Cannery Row and in and around his old laboratory.

MONTEREY CUSTOM HOUSE

The Monterey Custom House is California's oldest government building, having been built in 1821, and it became the first California Historical Landmark on June 1, 1932. In 1960, it was designated a National Historic Landmark. The Custom House is part of the Monterey State Historic Park. Mexico won independence from Spain the same year, and over the next twenty-five years, Monterey was part of the Mexican territory known as Alta California. Monterey was open for trade, and the Mexican government built the Custom House to collect taxes on imported goods such as sugar, coffee, tools, traps and many other items. During the Mexican-American War, Commodore John Drake Sloat claimed the Custom House and Alta California as part of the United States by raising the American flag. The Custom House served the same functions, only this time under American rule.

The Custom House is alive with many spirits, which wander the rooms and the stairs. Many sailors took refuge in the Custom House after their harrowing journey around Cape Horn. Visitors have seen some of the sailors sitting outside on the benches, only to vanish into thin air. The heavy aroma of cigar smoke and tobacco lingers in a bathroom at the Custom House. The story is that a Mexican man and a young boy were murdered in the building, and the two have been spotted numerous times passing

through the rooms or through the walls to the outdoors. When a family went to visit Monterey State Historic Park, the young daughter told her mom she was talking to a new friend who spoke Spanish. She described him as having bruises on his neck. The mother inquired about this child at the ranger's desk, but he explained that there is no such child and that he has had many inquiries about this boy in recent years. The mother is a believer in the spirit world and knew that her daughter was telling the truth without exaggeration. She returns to the Custom House hoping to see this little boy when she visits there.

Monterey's restless spirits appear at any time throughout the year and not just during the Halloween season and Día de los Muertos. Many sailors sought refuge at the Custom House after having made their grueling trip around Cape Horn, only not to survive after they reached land. The apparitions of sailors have been seen and heard in the Custom House, and visitors have been tapped on the shoulder only to turn around and no one is there. Footsteps are heard in the corridor or rooms when the Custom House is empty. The sight of a murdered man and his son have been reported as well. One lady screamed at the sight of what she said was the figure of a man hanging from the balcony; she was adamant when she explained that his body was swaying back and forth as though he were still alive and trying to free himself.

17 MILE DRIVE AND THE GHOST TREE

There is a site at Pescadero Point known as the Ghost Tree. Many of these cypress trees are dying trees and are white and twisted, and a person is reminded of ghosts when they see what is left of the once luscious cypress trees. There is one particular Ghost Tree that sits along the coastline of Pebble Beach, where the "Lady in Lace" has been seen on dark, foggy nights. Some motorists have claimed to have seen the Lady walking down the lane of 17 Mile Drive. Speculation abounds as to her identity; some claim it is Doña Maria, assessing her vast landholdings as she walks along 17 Mile Drive. Others see her as a jilted bride and claim that she is wearing a wedding dress. Down the road is the very famous Lone Cypress tree, and scientists have stated that the cypress and pine trees are infested with a beetle that will kill those trees over the next twenty-five years.

Hauntings at the Ghost Tree

The governor of California had given Doña Maria del Carmen Barreto Garcia Madariaga three large parcels of land that included Rancho Los Pinos, Rancho Pescadero and Rancho Manzanita. These forty-five thousand acres included Pebble Beach, Carmel and Pacific Grove. The property changed hands four times, and Maria had traded her three ranchos for a small adobe house to a man from San Francisco. When she learned that the properties had sold in excess of $45,000, she knew she had been swindled.

A Scottish dairyman by the name of David Jacks arrived in Monterey with the intent of owning the entire peninsula. With Maria's assistance, David Jacks put together a bill of sale claiming that the original sale was invalid, and he agreed that he would not claim the land until after Maria's death. She passed away in 1856, and he went to court to enforce his claim of the properties. He filed suit to enforce his claim, and the other owner, whose name was Gore, would not sell. Then, in 1906, the San Francisco Earthquake killed the entire Gore family, and Jacks won his lawsuit by default. Jacks set up a dairy farm in the Pebble Beach area and created the famous product Monterey Jack cheese.

There are those who claim that it is Maria's ghost that haunts 17 Mile Drive, as she is walking through her acres of land she had previously lost. Witnesses claim that her apparition sightings have been responsible for accidents along this road near the Ghost Tree area.

Other apparitions have been seen along the scenic Highway 1 along 17 Mile Drive. Late at night, a lady in white beckons alongside the road as she waits for a ride to nowhere. Visitors and other tourists see a woman dressed in a long white dress standing alongside the highway. It was an especially cold night when two college boys were driving along 17 Mile Drive and saw a woman next to the road. She seemed to be walking along the roadway. The boys pulled over a few feet in front of her, and both got out of their SUV as she approached them.

One asked her if she wanted a lift because it was too cold to be out. She approached them, a beautiful vision—she wore a long white cape with a hood, and her dark curls peeked out from around her hood. They noticed an odd aura of mist or fog around her, but they did not give it much thought. She consented to going with them. Her voice was soft, and she quietly explained that she was lost and needed to get back to her mother's house nearby.

They opened the door for her, and she climbed into the back seat of the SUV. They sped off into the darkness. Suddenly, without warning, the mist increased inside the car, and it became very wet and had a heavy odor of the sea and seaweed and rotting flesh. The driver pulled over, as he could barely see the road with all that fog clouding his view. The other young man had a coughing fit from the putrid odor in the car. As soon as he could, he opened the door, jumped out and tried to clear his lungs by breathing in the outside air. The driver opened the door to check on their passenger, and as soon as he did, he let out a scream. His friend rushed over and opened the other door, and he saw that she was gone. They both noticed that the back seat was wet, and there were pieces of seaweed on the floor and sand. Rough sand was on the seat as well. The woman had disappeared. Had she returned to the sea? Is this where she came from? Other travelers have shared their stories of meeting the Lady in White along 17 Mile Drive.

COLTON HALL

Colton Hall was the first public building built under American rule. Walter Colton had Colton Hall built for Monterey as a government center, and it also served as Monterey's first school. In 1849, California delegates attended the first Constitutional Convention at Colton Hall to move forward the plan for California to become a state. The delegates determined the size, shape and location of the state capital. Today, Colton Hall is owned by the City of Monterey and serves as a museum. Accounts in local history explain that convicted criminals were hanged from the second-floor balcony. Visitors to Colton Hall have encountered the ghosts and spirits of some of these dead men. One taps people on the shoulder. Cold spots are common, as are disembodied voices. Footsteps follow people when no one else is around.

NAVAL POSTGRADUATE SCHOOL, FORMERLY THE HOTEL DEL MONTE

The ghost of Charles Crocker is suspected of haunting the main building now known as Herrmann Hall. A middle-aged man, with a gray beard and wearing a gray suit, has been seen walking throughout the kitchen and

banquet hall. His apparition has been seen often, and it was Charles Crocker who helped finance the construction of the original Hotel Del Monte in 1880. There is an old elevator near the front of Herrmann Hall that has to be operated from the inside. Witnesses have seen the elevator go up and down between floors with no one inside. The lights go on and off by themselves and the doors open and close on their own. Unseen forces permeate this once elegant hotel for the rich and famous, and these same forces move dishes and glasses and objects such as chairs and serving carts. Visitors report having been tapped on the shoulder by invisible hands. Many claim to have seen the apparition of a person near the tower and once it is noticed, it dissipates into thin air before the observer's eyes. Specters of past visitors wander throughout and they are dressed in Victorian gowns or old-fashioned suits and hats. They walk the halls mostly at night and vanish into the walls or doors.

THE MONTEREY HOTEL

An elegant hotel built in 1904, this structure houses several resident spirits and ghosts. Fred, as he is known to the staff, passed away as a result of an accident at the hotel; he was a maintenance worker there, and he still returns to room 217 to this day. He has been seen walking about trying to fix the stairs throughout the hotel. Many claim to have seen the building's architect in the mirror facing the front desk; he reportedly passed away in 1936. In his image, he is well dressed in the finery of the day. The staff have seen a teenage girl sitting on the stairs, and her footsteps are heard as she walks down the hall of the upper floor. The telephone will ring at the front desk late at night from unoccupied rooms, and housekeeping has reported indentations of a person still imprinted on the beds in rooms that were vacant.

It's commonplace for a housekeeper to find cleaning supplies moved from one location to another while she is busy preparing the room for the next guest. Some have felt a tap or touch on the shoulder or arm. One lady explained that the hand that touched her arm was very cold and invisible, but she felt the touch of fingers and a palm on her arm.

LA PLAYA HOTEL IN CARMEL

The historic La Playa Hotel in Carmel, California, is home to two resident ghosts that have been seen walking through the gardens or on the terrace. The main structure was constructed in 1905 by Chris Jorgensen and his wife, Angela Ghirardelli, of the famous chocolate family of San Francisco. It is claimed that it was Angela's niece who drowned in Carmel Bay, and this tragedy was too much for Angela to bear. As a result, the family relocated to San Francisco in 1936. Today, the late Angela and her niece continue residing in the lovely Carmel home overlooking the sea. Angela is dressed in a long skirt, which was the fashion of the day, and her young niece is wearing a swimsuit from the early 1900s and has wet hair. Hotel guests describe them as "real" people that are seen sitting on the terrace or walking the gardens until they vanish into thin air.

The Jorgensens hosted artists, writers and many others at their home, as it became a popular salon for many creative types. Soon, they moved to Pebble Beach so they could enjoy more privacy. Agnes "Alice" Signor purchased the property, and she converted the mansion into a boardinghouse. The new name became The Strand, and in 1922, Signor had twenty more rooms added, making it a full-service hotel.

Howard "Bud" Allen purchased the hotel and introduced a full-time bar and other amenities, which made the hotel quite popular. Steve Jobs introduced the Macintosh computer prototype at a retreat for his development team at La Playa in 1983. The La Playa Hotel is known as the grand dame of Carmel.

THE HAUNTINGS OF CAPTAIN CASS'S HOUSE, THE COFFEE RICE HOUSE AND OTHER EERIE TALES

PITKIN-CONROW HOUSE IN ARROYO GRANDE

The beautiful Victorian house on Valley Road in Arroyo Grande was built in 1890 by the Pitkin family. Charles Pitkin married Julia Louis Goodwin in 1889. Although he was fifty-nine, he did not live that much longer, passing away on February 21, 1892. His funeral took place in the house's parlor.

Edgar and Abbie Conrow moved into the house in 1905 and lived there with their four children: MaryWest, Clayton, Gwyneth and Albert. One of the daughters, Mary, lived in the house until her death in 1952. The home changed owners four more times, but after 1994, when Crystal Properties took over, the ghost stories truly took hold and spread throughout the community. The new owners, Dona and Bonnie, renamed the house the Crystal Rose Inn. Sightings of a young girl between eight and ten years old have been reported. The child has been seen to be wearing a long dress with an apron, and her hair is in pigtails. She has been spotted in the upstairs tower room window. She has been seen playing with the ghost of a young boy in the Victorian house. Guests have heard laughter and voices coming from upstairs. Footsteps running down the stairs are also notable, or they run down the upstairs hallway. Common in the house are doors opening and closing by themselves. In the kitchen, dishes and glasses are rearranged, and fruit has been found scattered around the house as though taken for a snack to eat at a later time.

Here is the famous Pitkin-Conrow House. *Courtesy of Laura Dickinson.*

New owners took possession of the house and restored the Victorian home to its original splendor. They do not claim to have seen or heard anything paranormal, yet the sightings by others and the stories continue.

COFFEE RICE HOUSE IN OCEANO

The same architect who built the Pitkin-Conrow House in nearby Arroyo Grande also built the Coffee Rice House in 1885. The estate originally had extensive gardens, a racetrack, an oval driveway and additional buildings on the property. Today, it is surrounded by a mobile home park, and the home is no longer a sanitarium. The Rice family originally lived in the house. Coffee T. Rice moved to California from Ohio and settled along the Central Coast due to the railroad that was being planned to come through the area. The estate was completed in 1886, and it had beautiful marble bathtubs and sinks and Italian tile. The family lived in the house just about ten years because Rice's son was killed in an accident and Mrs. Rice became ill and died at a young age. The railroad was delayed and did not come through until 1895, and by this time, Rice had lost his fortune due to the construction delays of the railroad.

The Coffee T. Rice home, which was later converted to apartments. *Courtesy of Laura Dickinson.*

The home was acquired by the Temple of the People, which was a religious organization from Syracuse, New York. It relocated to Halcyon, an unincorporated area of San Luis Obispo County, in 1903. The Temple of the People operated the Coffee Rice House as a sanitarium until 1925. In 1959, new owners purchased the property and added the trailer park in front of the Victorian mansion. Then, other owners took over in 1959 and converted the second floor into apartments. Today, the house is in disrepair, and several windows are boarded up. The stories about the hauntings in this house are rampant. There are bloodstains that reappear after they have been washed away. This occurs in the foyer of the house. The former residents of the house reside there, as many have seen apparitions of these specters peeking out of the windows at night only to vanish in a shower of mist. Some have witnessed a man briskly walking about as if he were on his way to an important appointment. Then he disappears.

Some have seen the ghost of a man in a wheelchair and his nurse, seen pushing the chair around the house. Voices and muffled screams can be heard. Be aware that this is a private residence, and you do not want to be caught trespassing.

CAPTAIN CASS'S HOUSE IN CAYUCOS

The town of Cayucos was founded as a shipping port in 1867 by Captain James Cass. He was originally from New England and he settled on 320 acres at Rancho Moro y Cayucos Spanish Land Grant. Captain Cass, along with his partner, Captain Ingals, built the pier, a store and a warehouse that became a community center. Captain Cass had built his house that same year. His house has been renovated, and it is well known that Captain Cass still wanders his house, as he has been sighted numerous times. His ghost has been seen in the back of the house, mainly in the music room. Music has been heard coming from the room, the sounds of a piano and violin, yet there are no musical instruments there. Captain Cass had a niece who kept a diary, and she wrote about several ghostly activities in this diary. After her uncle had passed away, she and her husband entered the house and found a music box on the table. From the written account in the diary, this music box started up on its own.

THE BLACK STAGECOACH

The story of the black stagecoach is a local favorite, and it happened near Solvang, California. Two couples were traveling to Solvang for an overnight stay because they were going wine tasting the next day. The area is rich with wineries, and tourists often enjoy the wines and the platters of tasty food. Many purchase the wines as gifts or for their own personal wine cellars. This particular night was glorious, and in the spring, all the flowers bloom and the aroma of jasmine and lavender fills the air.

The couples had checked into their hotel and soon drove off to find a particular restaurant for dinner. The two ladies were sitting in the back, chatting away and laughing as they shared funny stories about their childhoods and their children. The husbands were discussing sports. They were in the lone car on this back road in Santa Ynez when Tom shouted, "What the...what is that?" Jeremy's eyes were wide open, his expression shock and surprise. Cynthia and Lacey saw the horses behind them first. "It's a stagecoach. What is it doing way out here?" Cynthia again exclaimed, "Look, the driver is wearing black, and he has no face!" You could not mistake the skeletal features of a skull and the bony fingers holding on to the reins. Tom slowed down to a crawl, and each person feasted their eyes on this strange sight. It could have been an eighteenth-century funeral hearse stagecoach; the carriage and the horses were all black. They galloped past the car and into the darkness at lightning speed. The car's headlights spotlighted the carriage, and Tom picked up speed as he attempted to follow it. Then, as suddenly as it appeared, it vanished in the blackness of the night. The headlights shined into the darkness, but only an empty road lay ahead. What happened to the stagecoach? Where did it go? Where did it come from?

The couples could not stop talking about what they saw. Yes, they were frightened, but it was easier to think that someone was playing a trick on them. They decided to turn back and go and have dinner at their hotel. After a long day, they welcomed the friendly atmosphere, and relaxing by the fire was soothing for them.

Seated at the table behind them were a man and a woman, and they seemed to be arguing. "I saw what I saw! The driver was a ghost. He was a skeleton ghost, and that carriage doesn't belong to this time. It has to be lost in a time warp or something. You saw it too, but you cannot explain it and there lies your fear!" Cynthia and Lacey stood up, walked over to her and told her that they had seen the same black stagecoach a few hours earlier.

Witnesses have seen this phantom black stagecoach racing along the back roads of Santa Ynez, and they tell the same story about the faceless driver. Although he is dressed in black, his head is a skull, and his bony fingers hold the reins of the six black horses.

THE HISTORIC SANTA MARIA INN AND ITS INVISIBLE GUESTS

This luxurious hotel was built in 1917, and it is located in the city of Santa Maria. Guests of William Randolph Hearst and Marion Davies would spend the night at the inn prior to their arrival at Hearst Castle. William always provided accommodations and transportation for his guests to the Castle. Many would arrive on the train in Santa Maria and spend the night at the Santa Maria Inn. A driver would be sent to pick up the guests and take them to San Simeon. The luxurious hotel began with 24 rooms—today there are 164. Other notable guests included William Randolph Hearst himself and Marion Davies, his domestic partner, as William was still married. Also staying at the inn were President Herbert Hoover and Cecil B. DeMille, who stayed in 1923 while he was filming the silent epic *The Ten Commandments* in nearby Guadalupe, California. If someone from the famous set stayed in a room, it is marked with a star, and the name of the famous person who stayed there is displayed, including the likes of Mary Pickford and Douglas Fairbanks, Charlie Chaplin, Rudolph Valentino, Bing Crosby, Bob Hope, Joan Crawford and Lee Marvin, among others.

The Santa Maria Inn is also very haunted. The ghost of Rudolph Valentino is said to knock on the door of his former room, and when the door is opened, an invisible presence walks into the room and reclines on the bed. The guests see the presence make an impression on the bed covers as it reclines. There are rumors that a ghost of a sea captain who was murdered by his mistress also appears in the hotel. The sea captain is seen wearing his uniform when he materializes. There is a piano that plays by itself, and numerous guests have witnessed this. Footprints appear in the garden while no human being is there. Guests have heard disembodied voices and laughter in the garden. There are reports of perfume and other scents in the rooms, clock hands have been seen spinning on their own and music has been heard coming out of disconnected speakers. The hotel has an elevator that starts up and

goes to the same floor on a regular basis. Apparitions have been seen in the gardens and the cellar. Rooms suddenly become ice cold without explanation, only to return to normal temperatures after a few minutes. The older, original part of the hotel is haunted.

SANTA MARIA HIGH SCHOOL'S HAUNTED THEATER

Ethel Pope Auditorium is part of the Santa Maria High School, having been built in 1892 and then rebuilt in 1920. The school was remodeled in 1971 following an earthquake, which also demolished the bell tower. The Ethel Pope Auditorium is haunted and has been since the 1920s. A senior by the name of Jeannette loved drama, yet she only landed smaller acting roles. She practiced and studied hard for the role of Juliet in Shakespeare's *Romeo and Juliet*, and she was awarded the part. Her endless rehearsals helped her in creating the perfect Juliet. The townspeople of Santa Maria have shared a story over the years that goes like this: Jeannette rode her bicycle to the auditorium on opening night. She performed her role perfectly in each scene and repeated all her lines seamlessly. The audience gave her a standing ovation at the end and the customary bouquet of flowers. Jeannette did not stick around, leaving immediately, and she did not celebrate her success with her co-stars. The following morning, Jeannette's mother telephoned the school and told the principal that Jeannette never made it to the auditorium because she had been hit by a car and killed as she was riding her bicycle on her way there. She was thrown off the bicycle and died at the scene. Of course, the principal and other school officials were in shock, as they had witnessed her amazing performance the night before. Another story is that Jeannette hanged herself from the catwalk above the stage, as many students and adults have seen a young woman walking back and forth on the catwalk only to disappear when she is noticed. Teachers and students alike have seen her walking across the stage or sitting in front of the mirror in the dressing room.

LOMPOC FURNITURE MART

They say that in Lompoc, this building used to house the town morgue. The ghost of a woman haunts the furniture mart, and she has been seen and heard throughout the store. Customers and store clerks have seen her, and she has reached out and grabbed ankles of people when they walk past her. When the store manager returns in the mornings to open for business, chairs are often rearranged and moved around. Cushions are scattered on the floor, but there is no sign of a break-in. They believe it is the ghost of the woman that resides there. Perhaps she worked at the morgue or was a "patient" there. Either way, its unsettling.

The historical building that houses the Lompoc Furniture Mart. *Courtesy of Laura Dickinson.*

GHOSTS OF OTHER LANDMARKS FROM VENTURA TO MONTEREY

CITY HALL IN VENTURA

The majestic statue of Father Serra stands in front of the Buenaventura City Hall, which houses the departments where the City of Ventura conducts business. Perched on a hillside overlooking California Street, one has a view of the city all the way to the ocean. This building served as the Ventura County Courthouse, the Sheriff's Office and the jail. It was designed by architect Albert C. Martin and built in 1912.

The sensational trial of Elizabeth "Ma" Duncan was held here in 1958. She was accused of hiring two thugs to murder her pregnant daughter-in-law, Olga Kupczyk. After they committed the deed, they dumped her body near Ojai. Before "Ma" Duncan hired the men to kill her family member, she hired a man to impersonate her son while she dressed up as Olga at an annulment hearing. She was quite determined to end her son's marriage. During the trial, her son, Frank Duncan, an attorney in Santa Barbara, helped to defend her. Frank's behavior was just as bizarre as the details of the crime because during the trial, he remarried. "Ma" Duncan was found guilty, and the two hitmen were also brought to justice. "Ma" Duncan was the last woman to be executed in the state of California, dying in the gas chamber in San Quentin.

Many claim that her ghost still resides in the former courtroom at Ventura City Hall. Ventura City Council meetings are held there, along with

The well-known statue of Saint Junípero Serra in front of the Ventura City Hall, which used to be the courthouse; a women's jail was housed on the third floor. *Courtesy of Laura Dickinson.*

Ventura City Hall sits overlooking the city of San Buenaventura. *Courtesy of Laura Dickinson.*

numerous other functions. Sometimes an unexplained knock will come from the corner of the room, and at other times a knock can be heard coming from the outer wall. Her ghost has been seen pacing the hallway closest to this former courtroom, and it is thought to be "Ma" Duncan.

The third floor of this building housed the women's jail, and today the space is used for storage. Several employees have encountered the ghost of the woman that haunts the jail to this day. Local lore says that the woman hanged herself in her jail cell. According to the story, she missed her children, who could not come to see her or pay her a visit, and she became despondent and depressed. A guard found her body, but she was already dead. This woman is an active spirit at Ventura City Hall, but there are others.

ELIZABETH BARD MEMORIAL HOSPITAL

The ghost of Dr. Cephas Bard has been seen and heard many times by those who rent office space in this building, which was named for Elizabeth Bard. Thomas R. Bard and his brother, Dr. Cephas Little Bard, established the hospital as a memorial to their mother, Elizabeth Bard. Dr. Cephas Bard is considered the first physician in Ventura County, and he is the first patient to have died in the Bard Hospital. This building is Historic Landmark No. 19 and was listed in the National Register of Historic Places in 1977. The Los Angeles Conservancy holds a conservation easement protecting the hospital's façade.

A young Ventura woman recalled a story her mother used to tell her. A long time ago, in the 1930s, this woman's mother and her siblings were taken to the Bard Hospital because there was a small orphanage next to it. They were three children in all—two girls and the toddler, a boy. Their mother had lost her way for a while, and the State of California stepped in, after which they became wards of the state. They lived in the orphanage for almost six months, and then they could return to their mother. Two of them walked to the local school nearby—known as the May Henning School, at 100 East Santa Clara Street—while the youngest remained and played with the other children.

One night, the middle child, the little girl, woke up her older sister and told her that she had seen a ghost. She was afraid and shaking. The older sister told her that she was having bad dreams, but she could climb into bed with her and would not be scared anymore. At night, it is an eerie place. The

This page: The Elizabeth Bard Memorial Hospital building, which now houses offices. *Courtesy of Laura Dickinson.*

light and shadows surrounding the backside of the building. Although it has a commanding view of the city and the ocean, one has a sense of foreboding when walking up there at night. Perhaps the restless spirits linger because they died within the hospital walls and the surrounding area. It could be that they have not crossed over. Many Chumash lived all along the Ventura hillsides, as they were part of the Mission San Buenaventura population in the early 1800s.

The following night, the two girls decided to just sleep together so as not to be woken up in the middle of the night by a nightmare. Then, in the early hours of the morning, something stirred them. They both felt something or someone touching their hair and pulling on it. The older one shot up and jumped out of bed. She found the light switch, and as soon as she turned on the light, she heard a deep growl and then silence. Both girls ran down the hall to their caregiver's room and woke her. Terror was written all over their faces. The younger sister explained that she had seen a monster and it had pulled at her hair when she was asleep. After investigating this incident, the caregiver allowed the girls to sleep with the lights on for the remainder of their stay in this orphanage. The creature did not visit them again.

One of the secretaries who worked in a downstairs office in the Bard Hospital Building was working late one evening. She suddenly smelled the thick aroma of cigar smoke and tobacco. When she looked up, she saw the apparition of a man wearing a white coat, and he had a stethoscope around his neck. Could this be Dr. Bard? She watched him as he walked out of the room and disappeared down the hallway. Others have seen his apparition in various areas of the Bard Hospital Building.

BELLA MAGGIORE INN

One of the most haunted locations in Ventura, California, is the Bella Maggiore Inn on California Street in downtown Ventura. This seaside community boasts many hauntings and haunted locales, but a favorite resides at the inn. In the 1940s, a "lady of the night" by the name of Sylvia Michaels entertained her clients at the Bella Maggiore Inn, and one morning, Sylvia was found hanging in her room, no. 17. Many guests who stay at the inn have encountered Sylvia. If a man stays in room 17, she has been known to knock on the door, and when the guest opens it, he may see her apparition or he may be hit with a strong scent of her rose perfume.

Lisa, a frequent guest of the Bella Maggiore Inn, says that she stays there regularly when she is in town on business. One night, after she hosted her parents and some friends for dinner at the Italian restaurant across the street from the inn, she decided to retire early since she had a series of meetings to attend the following day. Lisa was making her way up the stairs and down the hallway to her room when she was greeted by a strong whiff of perfume. It really was overpowering. After making her way inside, she dropped into a cozy chair in front of the fireplace. Once she showered, she knew she could relax by the fire and read a new mystery thriller she had brought with her. After calling her husband and daughters at home, she relaxed with her book. The night was still and quiet. The moon was full, and when she looked out the window, the view of the Pacific Ocean shimmered like silver silk hugging the earth. Her reverie was interrupted by something standing next to her. Her peripheral vision caught a shock of a blue dress or something made with that color. It was suddenly cold, and she shivered with fear. Even her robe was not enough to keep her warm. She grabbed her cellphone and room key and ran down to the front desk. The attendant read the fear on her face and he asked her, "Did you meet Sylvia?…Yes, of course you did."

He offered Lisa a cup of hot tea and sat her down near the fireplace where she could keep warm. He proceeded to recount the various guests who had met Sylvia—some met her in their rooms, others saw her apparition while others still only caught a whiff of her perfume. He walked her back upstairs, and the scent of rose perfume was so heavy in the air that other guests walking down the hallway stopped and remarked that they smelled the perfume as well. Each shared his or her version of Sylvia's ghost. They walked the guest back inside her room; she had calmed down by then. After everyone left, she left the lights on, turned off the fireplace and slept on the couch. She did not want to be alone in the bedroom that night. She has since returned to the Bella Maggiore Inn and stayed in a different room, and in the middle of the night, she was awakened by something or someone tugging at her feet through the blankets.

She sat up in bed and saw an outline of a person, a dark shadow just standing at the foot of the bed. After she reached for the lamp and flooded the room with light, the shadow person disappeared. She checked the bathroom and closets—all were empty. This time, she slept with all the lights on and decided that she had had enough fear and encountering spirits for a while. Lisa has not had to return to Ventura in nearly a year, but perhaps she will find lodging elsewhere—or she may just keep the lights on all day and all night.

THE TAVERN (FORMERLY KNOWN AS THE BIG GREEN HOUSE OR THE CARLO HAHN HOUSE)

The Tavern is a favorite haunt of many locals in the Ventura area. "Rosa" is the apparition seen by guests in the upstairs powder room. The scent of lavender permeates the air when there is a sighting. She was waiting for the love of her life to return from his duty at sea, but he never returned. She was so despondent that she hanged herself. Some patrons have seen her image in the mirror, and others have seen her apparition materialize before them only to disappear within seconds. The usual manifestations occur to let you know that you are not alone. The bartender has witnessed glasses moving by themselves and various empty chairs moving on their own. The lights turn on and off late at night, usually around closing time.

OLIVAS ADOBE

The Olivas Adobe is a lovely place to visit, and at night, you will be accompanied by several resident spirits. The ghost of Maria Olivas is often seen upstairs and also in the garden. Disembodied voices are heard along with children's laughter. The sounds of footsteps are distinguishable inside the adobe when there is no one else there. It is truly a haunted historic place.

WALMART STORE IN OXNARD

The ghost of a little girl who is about seven or eight has been seen playing in the aisles at this Walmart store. She has been described as wearing a blue dress and having pigtails. Her favorited play area is the toy department, and balls have been seen bouncing on their own and other items are taken off the shelves by an unseen force. She talks to the employees, and it is known that she giggle and laughs. Many have heard the disembodied laughter and her footsteps as she runs through the toy aisles.

SANTA CLARA HIGH SCHOOL

Ghosts have been seen roaming through the halls late at night. Witnesses have seen hooded figures floating down the corridors. Sounds of a basketball are heard inside the gym late at night. Locker doors are heard opening and closing, and lights turn themselves on and off. Other manifestations include voices emanating from what is now an old chapel that is no longer used.

VENTURA HIGH SCHOOL AUDITORIUM

Young adults haunt the school theater, and the mist of a young man has been seen manifesting at various times throughout the year. The theater is used for plays and music productions throughout the year for school and community functions. A young man known as Toby allegedly hanged himself from the catwalk, and he still resides in the theater. During school productions, his ghost will appear backstage and in dressing rooms, only to vanish when he is noticed. He seems friendly and not a threat to anyone, as the students have learned to work around him. One afternoon during rehearsal, one young lady could not find her script. She was searching everywhere, but to no avail. When she returned to the dressing room, there it was on the chair. She had previously searched this room, and it was not there then. Her explanation is that the ghost left it for her.

VENTURA CEMETERY PARK

This is a very haunted cemetery along Main Street in Ventura. Orbs are seen at night, and apparitions are common here. Beware of this place after midnight. A young man hanged himself from a tree branch at the cemetery and has occasionally been seen hanging, only to vanish.

MAJESTIC THEATRE

In downtown Ventura, the Majestic Theatre is home to a multitude of spirits and ghosts. There is a claim that all theaters are haunted, and this site is no exception. After dark, many have witnessed apparitions that suddenly disappear. A woman in a white dress dances across the stage, and some even claim that she is headless. Several male ghosts walk through the theater dressed in old-fashioned attire. Phantom shadows are seen along the walls.

FATHER SERRA CROSS (ST. SERRA)

Grant Park is home to the Father Serra Cross, which overlooks the city of Ventura. A Native American woman dressed in a white Victorian nightgown lurks around the cross after midnight. She has been seen many times, only to disappear when she is approached. A Spanish soldier assaulted and strangled her in the 1800s, and he buried her body near the cross. She has been seen wandering in the park ever since.

ARE MIRRORS PORTALS TO THE SPIRIT REALM?

Ever since man could see his reflection, he has been fascinated with viewing his likeness. It was often thought that it was because of magic that he could see himself. There is a fascination and a fear of reflective surfaces, and we have sometimes been warned by others that mirrors serve as portals to the spirit realm and to other unknown dimensions—but are they? It was believed that mirrors had the power to take souls, and if one looked into a mirror at night, he or she would see demons and ghosts in it. When people died at home, members of the household would cover mirrors or turn them facing the walls, or else the dead person would be trapped in the underworld. It was often thought that at night, one should cover any mirrors so that the negative forces could not attack you while you slept.

The most common story about a haunted mirror is when images of others are seen in the mirror when those people are not present in the room. More than one person has reported such unusual activity and sightings. There was a group of skeptics that visited a supposedly haunted hotel one evening.

The group had dinner in the dining room, and one member of the group asked the waiter if it was true that this particular hotel was haunted and if he knew anything about it. To this the waiter explained that after the manager closes up the kitchen for the night, he would have all the tables set in the dining room and everything would be neat and tidy. But upon returning in the morning, the tables would often be moved around, he would find silverware scattered throughout the dining room floor and the table napkins and tablecloths would be disturbed. Soon after, they set up surveillance cameras to see who was entering the kitchen and dining area after closing.

When the manager arrived the morning after the cameras had been set up, the dining room was messier than ever. Everything had been disturbed—even the chairs were askew or turned over. He and the other managers viewed the surveillance tape. Lo and behold, no one was visible on the video. The items moved by themselves! Invisible fingers knocked over the chairs and removed the silverware and tablecloths. The time stamp read 3:00 a.m.

The skeptics were somewhat surprised and taken aback, but the story did not sway them into believing in ghosts and spirits. They retired to their rooms soon after and settled in for the night. John, the ringleader of the group, chose to sleep in the allegedly haunted room, 405, on the fourth floor. He always believed that ghosts were made up and not real—"just a bunch of malarkey," as he often repeated as he belittled ghost sightings or tales. That night, John's life changed forever.

A hissing sound disturbed John's sleep. He tossed and turned, thinking he could tune out that sound from the TV. Was it his imagination, or was it getting louder? It seemed to be right next to him and was quite loud, as if it were magnified one hundred times. When he sat up in bed, the sound stopped. He convinced himself that it was a weird dream. He rose from his slumber and went to the bathroom. Splashing cold water on his face could help. Now he was awake, and the clock read 2:30 a.m. He drank some water, turned on the TV and tried to relax. Nothing but boring news to put one to sleep—that was his remedy. His eyelids became heavy, and he lay back and rested his head on the pillows. The room was dark with the exception of the glare from the television.

Suddenly, without warning, he heard the hissing sound again. Without thinking, he got out of bed and searched for the remote to shut off the television. The images on the screen were not the news stories—the images were not in color, and there was no sound. The image was dark and looked like a shadow with a hat on the screen, set against the gray background. Terror seized him when the shadow stepped out of the television and began

CALIFORNIA'S HAUNTED CENTRAL COAST

hissing. The Shadow Man moved about the room as though searching for something. He stepped through the door into the bathroom, and John could hear him moving things about, like the shower curtain and hair dryer. When the Shadow Man stepped through the door and was standing before him next to his bed, that's when John made a run for it. He swung open his door and ran down the hallway yelling, "I'm a believer now. I'm a believer now. Leave me alone!"

The next morning, the group gathered for breakfast in the dining room. All but John were there. The manager went over to John's friends when they were eating breakfast and mentioned to them that the oddest thing happened early that morning. "Your friend John checked out very early, and he asked that I tell you that now he is a believer."

"A believer? You mean he now believes in ghosts? Did he tell you what happened?"

The manager responded, "No, but he did say, he is getting rid of all of his televisions in his house—something about a shadow man and a hissing sound. When housekeeping entered his room to prepare it for the next guest, they found the bathroom mirrors broken and cracked, as well as the television screen. There was a foul odor in that room, and there were oil and tar stains on the carpet. It was very unusual."

When the group returned home and went over to visit John, his house was empty. They peeked through the windows, and all the furniture was gone. There was no sign of John anywhere. He simply disappeared, and they never heard from him again. Not long after the hotel incident, the group began seeing images of people in their mirrors in their homes, but the images were of people not present in their house. Another saw a white mist in the mirror, and the mist morphed into the face of a woman. They speculated that this must have been something John saw and experienced at the hotel. They wanted to smash their mirrors as well, but they did not. They all became believers, and they are hoping that John will return someday.

WHAT ARE PORTALS?

Many believe that portals are windows or two-way pathways for both entering and leaving the spiritual realm and dimensions to the physical world. It is claimed that negative energy or negative spirits come through portals. High levels of activity are found near portals, such as ghosts or images in mirrors.

They are not limited to mirrors, and many claim that portals exist all over the world. It is claimed that not only spiritual beings but also aliens and beings from other dimensions use portals. There are those who state that they have seen portals in photographs, and they appear as a swirling shape similar to a whirlwind. Some believe that portals exist in windows, cupboards, doorways and closets. Others do not believe portals exist at all but accept that a vortex exists—a band of energy, not positive or negative but neutral, where one can meditate or offer prayer and engage in other spiritual work.

If your grandmother or someone you know has a mirror that is ornate and gives you the shivers, your instincts may be warning you about something—be aware that something may be looking back at you.

THE LEGEND OF LA LLORONA AND LAKE CACHUMA

There have been numerous sightings of the "Wailing Woman" throughout the southwestern United States and in Mexico. There are many versions of this scary tale of a woman who drowned her children and then herself. She returns to the world in search of them, and she can be seen wailing along the shores of lakes, rivers and streams, calling out for her children: "*Ayyyy, mis hijos, ayyyyyy.*" It is terrifying when you hear her cries. This tale has been attributed to the Náhuatl people of the Aztec empire in Mexico.

Cries and wailing have been heard in the very early morning hours along the shores of Lake Cachuma in Santa Barbara and along the many rivers of the Central Coast of California. There are those who have seen La Llorona as she walks along the Santa Clara River in neighboring Ventura County, within the boundaries of Rancho Sespe and the Fillmore City Limits. Her cries have resonated along San Antonio Creek in the Ojai Valley. In Lompoc, where Mission La Purísima was founded, the plaque in the area reads, "Mission Concepción de María Santísima was founded here on December 8, 1787, 11th of the eventually 21 missions." This mission site is designated as State Historical Landmark no. 928.

The Santa Ynez River winds through Lompoc and Vandenberg Air Force Base, and many sightings of the Wailing Woman have been reported along her shores. After heavy rains, she has been seen searching for the children she drowned.

One man described the night he met La Llorona. It had been raining all day, and Thomas was working overtime, helping his boss organize files and

setting up the network on the new office computers. The clock read 11:15 p.m. when the boss told Thomas to go on home because everything was functioning and ready to go for the morning. He left Santa Ynez and made his way traveling down Highway 150 toward Santa Barbara. The rain let up for a while, but the wet road was still treacherous as he wove his way around in his large pickup. His wife insisted that he get the large pickup truck because she knew it would be safer to drive under bad weather conditions. Up ahead he made out the sign that announced he was approaching Lake Cachuma. It was so late and so dark, and he still had another fifteen miles to go until he was home. His cab was warm, and he turned on the radio to help him stay alert. He also rolled the window halfway down to prevent him from getting too sleepy. Then, straight ahead, his headlights illuminated what looked like a person walking alongside the rode. He slowed down as he approached this figure he could barely make out in the middle of the drizzling rain and darkness. Nobody should be out in weather such as this. He thought he should help this poor woman. He assumed that perhaps she had car trouble or was caught in a situation where she had to go walking somewhere.

He stopped his truck a few feet ahead of her. The roadway was clear, with no other cars approaching, so he felt comfortable that no one would hit his truck. He turned on his high beams just to be sure he could be seen. He rolled down the passenger-side window, and the woman walked toward the truck. "Hello, do you need a ride somewhere? It's too cold and dangerous to be walking along the road tonight."

She stepped up to the open window and peered inside the cab. Water was dripping on the seat from her long black hair. He could not see her face. Again, he asked her if he could take her to wherever she was going. She did not respond. Then he saw her fingers on the door—only they were not fingers; it was a skeletal hand. The woman looked straight at him, and he saw a skeleton face with empty eye sockets. He yelled in fright. Instantly, he powered all the windows to close, and the passenger window caught her skeleton hand. He released the window and let it down, and two bony fingers fell onto the passenger seat. The skeleton woman walked to the front of the truck and made her way across the road toward Lake Cachuma. To his horror, she seemed to be floating instead of walking, and he heard a terrible wail. This creature let out a screech and cry that he had never heard before. He did not know people could make those sounds. *"Mis hijossssss, mis hijossssss, Ayyyyyyy…"*

It made his blood run cold. He stepped on the gas and took off down the road. Who would believe him if he ever told them he had encountered the

Wailing Woman, La Llorona? Thomas pulled off the road at the next turn out and tried to relax. Terror and fear enveloped him, and he did not want to drive off the rocky cliffs along Highway 150. Home is where he belonged, and off he went. He confessed to his wife what he had seen, and she believed him, as this was the first time she had witnessed this strong man show such fear. His emotions were normally positive, and he enjoyed laughing. He was a good father and husband. The couple agreed to keep the secret to themselves. She did not want her friends to start saying, "Tomas el Loco," "Crazy Thomas" or other insulting comments and names.

One year later, Thomas was driving home on Highway 150 when his pickup truck was clipped by another car as the other car tried to pass his truck. Thomas lost control of his truck, and it rolled over the side of the rocky cliff along Highway 150. The earth was still and silent, as if allowing Thomas to get a last word on his life's stage. When the search party made its way down to the accident scene, it found the banged-up truck and various items that had fallen out of the truck, such as a map, a flashlight, Thomas's wallet and a St. Christopher medal still clipped onto the side of the center console. After searching the surrounding area, there was no sign of Thomas. He was never found.

THE HAUNTING OF THE BLUEBIRD INN

On your way to Cambria, stop by and visit the Bluebird Inn in Cambria's East Village on Main Street. This was built by George Lull in 1880 for his second wife, Mary Inman Lull. Many visitors have seen the ghost of Mary Inman roaming through the house at night, and she also wanders in the garden. One visitor shared her tale of bumping into her late one night, and this is her story.

The visitor recounted in vivid detail that while her husband slept, she became restless and could not sleep. She grabbed her warm robe and slip-on tennis shoes and walked out into the garden. There was a foot bridge outside of their room, and she took it to see what she could see. It was a dark, moonless night, and everything was pitch black except for the lights shining from the inside of the Bluebird Inn. She found herself in a lush garden and sat down to gaze at the constellations. It was beautiful. No city lights impeded her view of the Big Dipper or the North Star. She saw them and also found Orion the Hunter and the Pleiades without any difficulty. Then

she heard a rustling of leaves close to her and turned around to see who was approaching. The leaves rustled as though someone were stepping on them, taking slow strides. From the shadows and the darkness, a lady appeared as a transparent entity. You could make out a body wearing a long dress and apron. Her hair was pinned up, and she looked as though she needed a rest too. Perhaps she was fatigued from all her chores that day. She watched the apparition walk through the wall into the lounge area of the Bluebird Inn.

She could not believe what she had just seen. She pinched her cheeks to check if she were indeed awake and rushed into the lounge to search for this spirit. When she walked inside, the bartender was cleaning up and stacking glasses. He asked her, "May I help you?"

She responded, "Did you see a lady walk in here just a few minutes ago? Actually, she appeared to be an apparition of a lady."

"No, miss, I did not, but you know, this place is haunted. You must be talking about the ghost of Mary Inman. She is seen around here frequently. She wanders around here, and she takes things and hides them. Then they turn up after a while. Strange."

"Thank you for that information. I thought I was losing my mind." She realized she should get back to her room, and when she walked inside, as she glanced at herself in the mirror, she noticed there was another face in the mirror looking back at her—it was the same ghost she had seen in the garden. It was the lady they call Mary Inman. Then, without warning, the image disappeared.

The woman was terrified but took a hot shower and went to bed. In the morning, she relayed everything to her husband, and they decided to leave. They have since returned to the quaint Bluebird Inn, only this time, she remains in her room and does not go off wandering around by herself.

THE STOKES ADOBE AND RESTAURANT 1833

James Stokes, an English sailor, purchased the adobe in 1834, one year after it was completed. He posed as a physician, and even though many of his patients died, Mexican governor Jose Figueroa became one of his patients (he also passed away). Jim Stokes's wife, Josefa, took ill and passed away in the upstairs bedroom. The staff and guests have witnessed Stokes's ghost in the kitchen and in various downstairs locations. Voices and footsteps are heard coming from the upstairs and from the room that allegedly belonged

to Josefa. After his wife's death, Stokes took his own life by ingesting poison. Another apparition seen in the downstairs bar area is former owner, Hattie Gragg. She was known as a socialite who enjoyed parties and entertaining her guests. She passed away in 1948 but never left this house. Restaurant guests and staff have experienced the lights flickering off and on and a woman that sits at the bar and then vanishes. The staff claim it is Hattie Gragg. Hattie plays the piano to this day and calls out staff names. It is unnerving when no one can be seen sitting at the piano pressing the keys. The spirits of James and Josefa Stokes as well as Hattie Gragg continue making the Stokes Adobe and Restaurant 1833 a very lively place.

CASA MUNRAS

Casa Munras was the first hacienda built outside the presidio in 1824. Spanish diplomat Esteban Munras named his new home La Granja, which means "The Farm." It was the center of his spacious twenty-thousand-acre Rancho San Vicente. Inside, the apparitions of Esteban Munras and his daughter have been seen throughout the now Casa Munras Garden Hotel and Spa. Today, part of the original adobe walls form part of the Marbella Meeting Room. Esteban's great-granddaughter, Maria Antonia Field, was the last of the Munras family to live in Monterey, and she passed away in 1962. She lived at Casa Munras until 1941, when Jack Dougherty and his family purchased it in order to build Monterey's first garden hotel.

MORRO BAY AND ITS HAUNTED SHORES

Morro Bay is a lovely city along the shores of the Pacific Ocean on Highway 1. There is the story of the ghost of Vincente Canet, who still haunts the Canet Adobe that he had built for himself. In the middle of the night, there are those who claim to hear him ride off on his horse down to Morro Rock. He was a colorful character and well educated when he jumped ship in Monterey in 1825. He married a wealthy, beautiful and well-connected young woman, Rosa Maria Josefa Butron y Dominguez, in 1828. In 1840, Rosa's relative, Governor Juan Bautista Alvarado, granted him the four-thousand-acre Rancho San Bernardo, which is five miles east of Morro Bay.

Morro Rock, which sits as part of Morro Bay. *Courtesy of Laura Dickinson.*

That is where he built his adobe. Unfortunately, he passed away in 1858, and his widow remarried. Visitors to the Canet Adobe will see it fully restored, and it is claimed to be very haunted by Canet. Strange noises can be heard around the house, and footsteps are heard when there aren't any visitors in the adobe. Those who have seen Vincente Canet ride his horse down to Morro Rock have described him as dressed in all his finery, and the horse is as swift and fast as any Thoroughbred. It is claimed that he was buried in the Canet family cemetery in Morro Bay. His desire was to be buried at the top of Morro Rock. He thought that Governor Alvarado should have granted him Rancho Moro y Cayucos in addition to the other rancho because Morro Rock is part of Rancho Moro.

ATASCADERO CITY HALL AND ITS RESIDENT SPIRITS

There are those who have witnessed the strange happenings and unexplained occurrences at the Atascadero City Hall. Items move from place to place without any explanation. A toilet flushes on its own when no one is in that bathroom. Many have heard this. When they investigate, no one is there.

Atascadero City Hall. *Courtesy of Laura Dickinson.*

Another view of Atascadero City Hall. *Courtesy of Laura Dickinson.*

A view of the rotunda inside Atascadero City Hall. *Courtesy of Laura Dickinson.*

Atascadero City Hall is a historical landmark. *Courtesy of Laura Dickinson.*

Others recall the time after a serious earthquake in the area—there was no electricity and no gas, and the emergency services people were in the building with flashlights because it was already dark. Without services, the lights did not work. Suddenly, they all heard music coming from upstairs. The music was described as sounding like a phonograph of some sort.

The building had been used for dances, a courthouse, a jail and a veterans' memorial building. When the group went upstairs to investigate who was playing the music, there was nothing to find. They heard it, but they could not explain it.

MADONNA INN

The famed Madonna Inn has its fair share of stories about spirits that visitors have seen or heard. People have heard voices speaking to them, and other guests have reported being tapped on the shoulder by invisible hands. The housekeeping staff have seen items move on their own. Many have shared that they are not fearful, as they sense it is a playful spirit.

CRONIES AND THE CHAIRS THAT MOVE ON THEIR OWN

In Ventura, California, Cronies Bar and Grill restaurant had some scary happenings that were caught on surveillance tapes. The manager came in one morning to open up and found a stool knocked over on the floor. There was no sign of anyone having broken in, so he checked around and all the windows were closed and locked. He decided that he would watch the surveillance footage to see who might have been inside the restaurant after it was closed. He was shocked to see the stool move on its own and fall over in the middle of the floor. Then, one week later, while patrons were enjoying their lunch, a chair moved on its own. The guests seated nearby saw the whole thing happen. The co-owner reviewed the surveillance footage and saw the chair move by itself as well. It's all captured on the tape. They posted the footage on Facebook and were interviewed on various news stations. On the walls at Cronies are the photographs of past patrons and employees who have since passed away. They say it's the spirits of their first two patrons whose photos are on the wall. This all happened in October 2017, just in time to usher in Halloween. One has to wonder how the ghosts at Cronies will celebrate Halloween this year.

THE HAUNTED TELEPHONE

In Santa Barbara, there is a lovely resort known as the Ritz-Carlton Bacara. Several people who worked at the resort when it was in its infancy described how guests would call the front desk and complain that their phones would ring but no one would be talking on the other end; it was a real nuisance for one guest. She said that it rang in the middle of the night. They sent up a telephone repairman and a resort security person to the woman's room. They worked on the wiring and changed out the telephone, and the repairman was carrying the broken telephone away when it rang as he held it. Then it rang again. It was not connected to a phone line or plugged into the wall. The security employee picked up the receiver, but no one was on the line. He did hear crackling, as though the phone line were connected. The repairman took the phone to the dumpster and disposed of it after he tried breaking it into pieces. They still remember the shock and fear from that telephone.

Other guests see a young woman jump off a second-story balcony, but when they go to rescue her, there isn't anyone there. The Chumash people resided in the area many years ago, and there are those who believe that the resort has the residual spirits of those Chumash natives who had passed on.

SELECTED BIBLIOGRAPHY

Books

Anaya, Rudolfo A. *The Legend of La Llorona*. Berkeley, CA: Tonariuh-Quinto Sol International Inc., 1984.

Davies, Marion, and Orson Welles. *The Times We Had: Life with William Randolph Hearst*. New York: Ballantine Books, 1985.

Nasaw, David. *The Chief: The Life of William Randolph Hearst*. N.p.: Mariner Books, 2001.

Sahaguin, Fray Bernardino. *Florentine Codex: General History of the Things of New Spain*. The School of American Research, Museum of New Mexico. Salt Lake City: University of Utah, 1953–82.

Sobek, Maria Herrera. *Chicano Folklore: A Handbook*. Westport, CT: Greenwood Press, 2006.

Ybarra, Evie. *Ghosts of Santa Barbara and the Ojai Valley*. Charleston, SC: The History Press, 2017.

———. *Ghosts of Ventura County's Heritage Valley*. Charleston, SC: The History Press, 2016.

Yeats, W.B., ed. *Fairy and Folk Tales of Ireland*. New York: Macmillan Publishing Company, 1983.

Articles

Smith, Grace Partridge. "Folklore from Egypt." *Hoosier Folklore* 5 (June 1946).

Web Resources

Jim Beckwourth. www.beckwourth.org/Biography/tragedy.html.

La Llorona. http://www.lallorona.com.

La Virgen de Guadalupe. http://www.mexconnect.com/mex_/travel/jking'jkguadalupe/html.

San Luis Obispo County. "Historic Attractions: Museums." www.slocal.com/things-to-do/attractions/historic-attractions-museums.

ABOUT THE AUTHOR

Evie Ybarra is the mother of two—a daughter and a son. She considers her two children her greatest accomplishments. Her husband and confidant, Robert, is her greatest supporter. Evie now has four beautiful grandchildren to whom she has told many stories. After having taught creative writing and history for thirty years, she now enjoys writing as a second career. Evie and her family reside in Southern California in a coastal community filled with many legends and stories.

Visit us at
www.historypress.com
···